ABANDONED VERMONT

DOWN FORGOTTEN BACKROADS

MARIE DESROSIERS

AMERICA THROUGH TIME®
ADDING COLOR TO AMERICAN HISTORY

America Through Time is an imprint of Fonthill Media LLC
www.through-time.com
office@through-time.com

Published by Arcadia Publishing by arrangement with Fonthill Media LLC
For all general information, please contact Arcadia Publishing:
Telephone: 843-853-2070
Fax: 843-853-0044
E-mail: sales@arcadiapublishing.com
For customer service and orders:
Toll-Free 1-888-313-2665

www.arcadiapublishing.com

First published 2021

Copyright © Marie Desrosiers 2021

ISBN 978-1-63499-331-9

Typeset in Trade Gothic 10pt on 15pt
Printed and bound in England

CONTENTS

ABOUT THE AUTHOR

MARIE DESROSIERS is a hobby photographer with a love and fascination for the forgotten and abandoned. Whenever possible, she seeks to find the history and stories behind the places she comes across. Marie spends much of her time driving down backroads to find the often-overlooked beauty and lost history in these abandoned homes, farms, and businesses. Where others may see crumbling structures, she finds unappreciated beauty that she documents in her photographs. She has a passion and determination to capture these places before nature reclaims them. She is hopeful that through these photos, these places can be truly seen and remembered, even briefly.

INTRODUCTION

When I was growing up, one of the houses I lived in had abandoned cottages behind it in the woods. My dad brought me out there one day to look around, but made me promise that I would never go back there without him. The things that were left behind made it seem as if they were never intended to be left forever, and that their owners would return, but they never did. The kitchen tables collected dirt and the dishes sat in the cabinets, never to be used again. The beds were made, waiting for someone to sleep in them, but they never came. They sat this way until, like many of these abandoned places, people came in and destroyed those dusty memories. For as long as I can remember, and probably partly because of those cottages, I've had a fascination with things that have been forgotten by others. As a child, I would find myself at the library, immersed in stories of abandonment and ghost towns. These stories left me daydreaming of one day seeing these kinds of places. Who lived there? What memories did they make? Why did they leave? To this day, I still ask these questions whenever I come across an abandoned house. Sometimes my research and conversations with others provides answers, but other times I'm left to just imagine.

Photographing abandonment has always made me feel that these places, though forgotten and discarded, are getting a moment to shine again and be noticed. The beautiful architecture and detailed woodwork get another chance to be appreciated, even if it's just through the lens of my camera. Through the decay and the dirt, I am able to see the beauty that once was, and I want others to see that as well. By getting lost in these forgotten places, I am able to find myself and look at life differently. When I first started photographing abandonment years ago, I wasn't entirely sure what I was doing, and I was only equipped with a cellphone that took

grainy photos. I've come a long way with the support and encouragement of my family, some friends, and my boyfriend. Being able to see these places has helped my hobby grow into a passion.

ABANDONED VERMONT: DOWN FORGOTTEN BACKROADS

Moving to rural Vermont, I found myself getting lost down old dirt roads. The rolling hills, old farmhouses, barns, and silos became familiar friends to see during my drives. A great deal of the abandonment that can be found here are houses with long familial history. Farms that were once the epicenters of production and noise now stand silent as their walls crumble and their roofs cave. The lack of noise can almost be haunting if you remember these spaces used to be so lively. There are quite a few places that hold a deep Vermont history that many people aren't familiar with, and that shouldn't be forgotten, even long after these structures are truly gone. Most of these abandoned places are crumbling on less traveled backroads, against a backdrop of beautiful mountains. It's hard to believe that they have withstood decades and centuries of harsh Vermont winters, but it's time for their stories to be told.

1

ABANDONED HISTORY

There are a few abandoned places I've come across in Vermont with interesting histories that have been left to fall apart. Learning the history of these places has been eye-opening, which has made it that much harder to understand why they aren't being preserved. One of the things I enjoy most about rural exploration, however, is that many of these places aren't as sought after or well-known, so there's less of a chance of them being damaged and exploited. A few places have found their way onto the historical register, but nothing much has been done to preserve their integrity.

In 1954, during the Cold War, an early detection site was built on top of a mountain in Vermont. The radar station was built to provide information and warnings of any signs of nuclear activity. A few miles below the radar station, tucked away at the base of the mountain, in metal huts, over 170 men lived and slept. The base also had buildings for a theater, bowling alley, store, barber shop, bar, and cafeteria. Despite the amenities provided to these men, I can only imagine how long the harsh Vermont winters felt in the remote wilderness of the mountain. The road up to the radar towers is steep and narrow and in the winter months, I imagine it's virtually impassable. Other bits of history surrounding the mountain are also interesting and tragic. In 1961 the station reported a UFO sighting lasting eighteen minutes. Subsequently, this happened only hours before the alleged famous abduction of Betty and Barney Hill in nearby New Hampshire. In 1969, four years after being sold to a private landowner, a snowmobiler was accidentally decapitated by a makeshift "gate" of cable wire. In 1990, another person met an untimely death when they fell from the top of one of the abandoned towers. The station, now unused, is nothing more than a crumbling memorial.

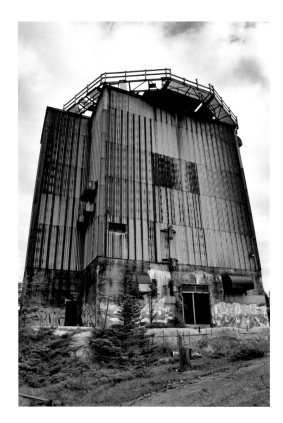

This was the first abandoned Cold War building I saw at the top of the mountain.

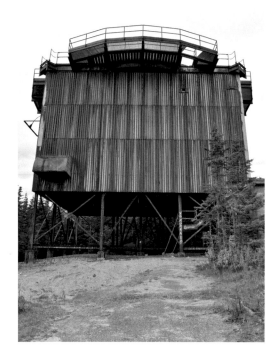

Another empty but rusting and rotting Cold War building.

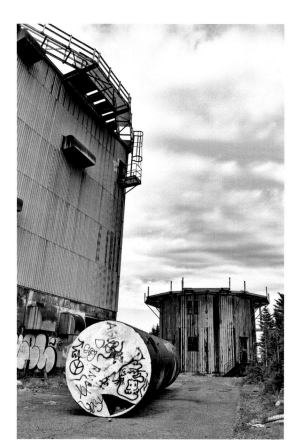

Right: Despite the difficulty getting to the top of the mountain, people have managed to tag a few of the buildings.

Below: Another abandoned building overlooking mountains off in the distance.

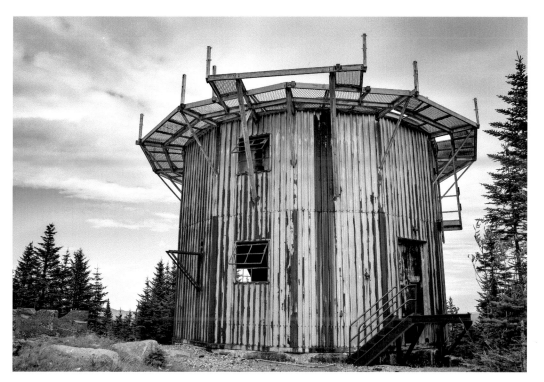

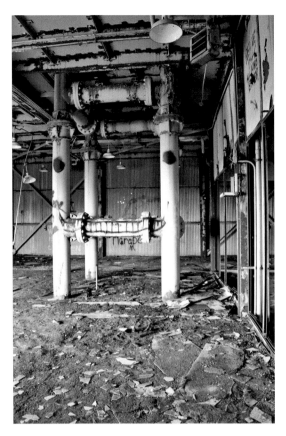

Left: The insides of most of the buildings looked similar.

Below: All of the buildings have lookout areas. It can get very windy at the top.

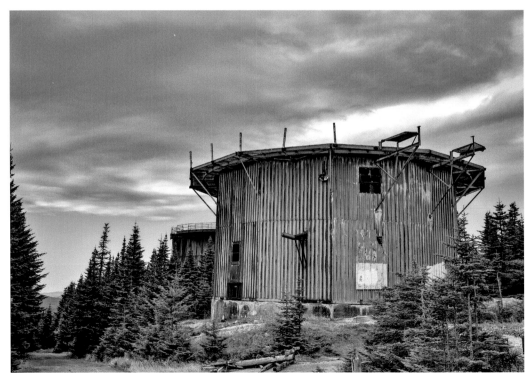

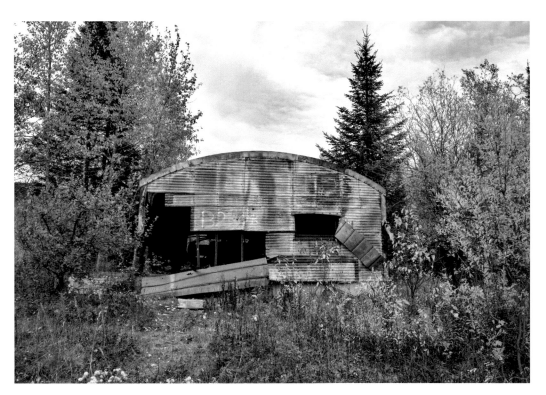

One of the buildings found at the base of the mountain, where the men lived.

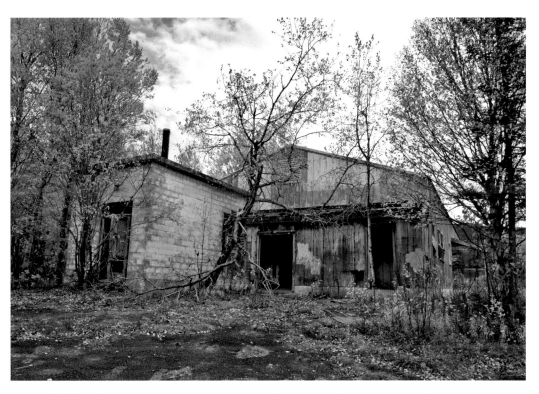

A building that was once used as a cafeteria to feed the men who lived and worked on the mountain.

This racetrack was in operation from 1963 until 1993. It was originally a horse racing track and later was replaced by greyhound racing. Due to pressure from animal rights activists, racing was discontinued shortly before Vermont banned dog racing completely in 1995. After the track was closed, it was still used for other events such as Lollapalooza in 1996 and antique car shows until 2008. Sadly, in the late evening hours on a September night in 2020, the entire building was gutted by a fire, taking any remaining history with it.

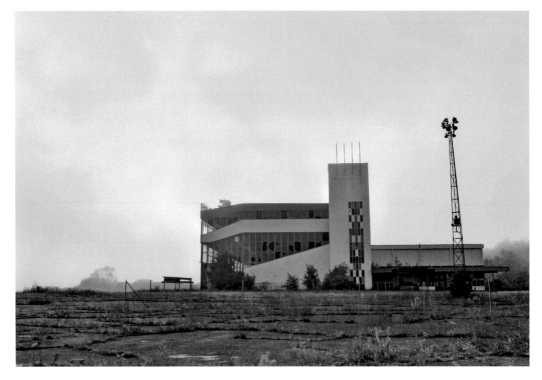

What the outside of the racetrack looked like before the fire.

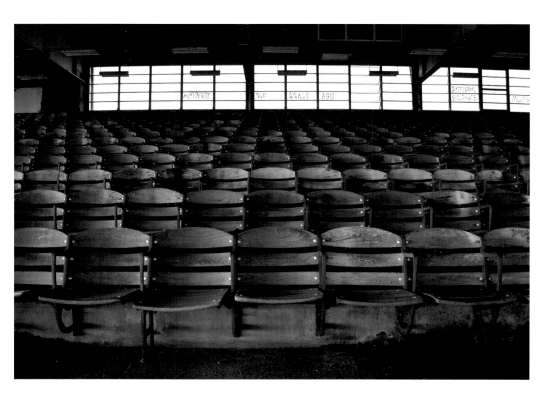

Above: The stadium seating found on the top level that overlooked the outside racetrack.

Right: One of the areas that had been flooded by rainwater.

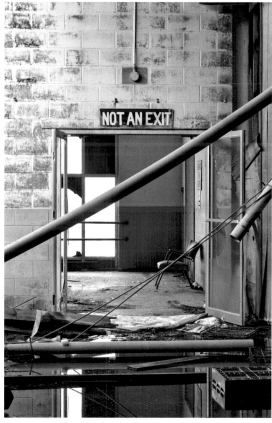

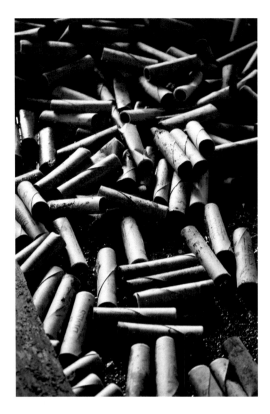

Left: In a closet I found a box full of these empty coin sleeves.

Below: The price of concessions has certainly gone up over the years.

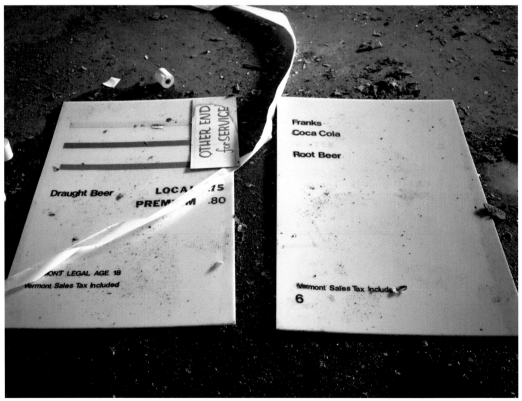

OTHER END
for SERVICE

Draught Beer LOCA.... 15
PREM.... M .80

...ONT LEGAL AGE 18
Vermont Sales Tax Included

Franks
Coca Cola

Root Beer

Vermont Sales Tax Includ...
6

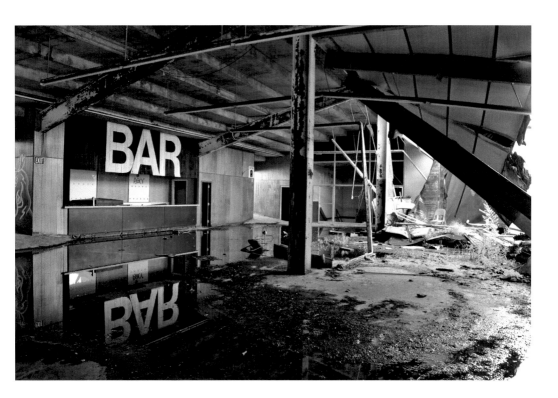

Above: Caved-in roof.

Right: A ticket box full of old ticket stubs.

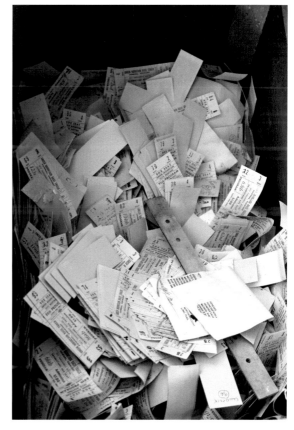

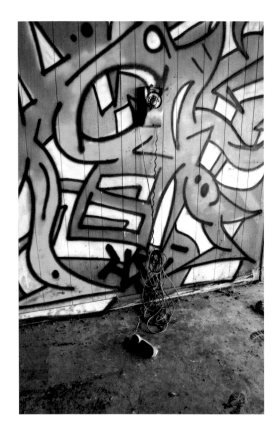

Left: An old telephone found on the wall in the concession area.

Below left: Moss and mold growing all around the building.

Below right: Reflections of the concession stands in the still water.

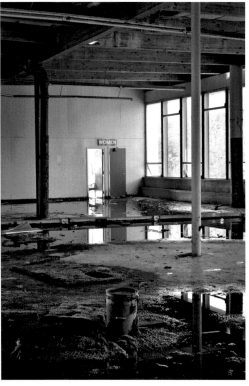

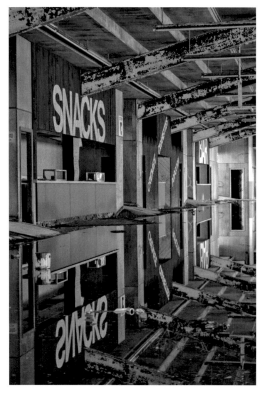

I n rural areas of Vermont, jobs aren't always easy to come by. Built in 1930, this hydroelectric plant served the area and provided jobs for locals for decades until it was shut down. Now it sits boarded up next to a popular fishing spot in the area.

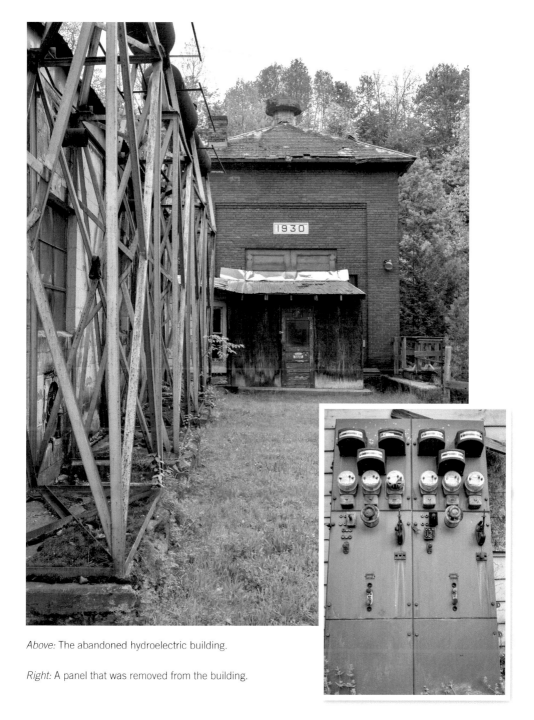

Above: The abandoned hydroelectric building.

Right: A panel that was removed from the building.

B uilt in 1941 for the Portland Pipeline Corp., this was once part of the Portland-Montreal pipeline that carried crude oil from South Portland, Maine, to Montreal. The property once included a Quonset hut, a boiler house, and eight single-family homes for workers and their families. Within recent years, local towns have opposed the reversal of the oil pipeline.

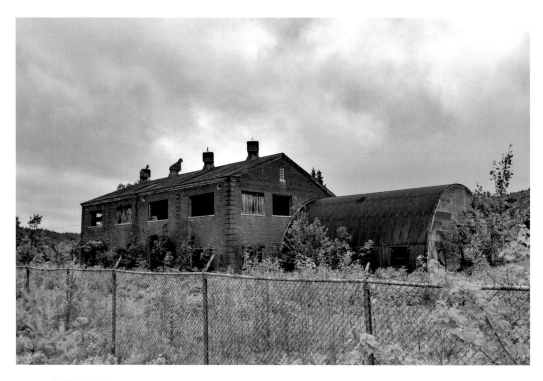

Behind the fence.

Elmer Darling, the owner of the Fifth Avenue Hotel in NYC, also owned two cottages in Vermont. In 1914 he gifted one of the cottages, that became known as Sunset View, to a group to use as a tearoom to raise money for several parks in the area. In 1921, he built a dance casino next door to the tearoom, which was also to be used for raising funds for local parks. Almost 500 people attended the opening night of the casino and danced well into the early morning hours to a seven-piece orchestra. In 1935, under new ownership, a restaurant was built underneath the dance hall. The dance casino has since been purchased and is being converted into a private residence. The tearoom still sits abandoned and is falling apart more and more with every passing season. The name is almost entirely gone on the large boulder that sits between the two buildings—a fading reminder of a much livelier time on the lake.

Falling further into disrepair.

The house was built in 1845, originally as a cottage, and eventually the Greek Revival addition was built in 1850. The owners started a business, focusing on the Elgin Springs, which they said had medicinal purposes. People from all over came to partake in the magical spring water that was touted as a way to purify blood. The many guests who stayed at the inn were encouraged to drink from the spring. Eventually, like most things do, this came to an end when it was realized that there was, in fact, no truth to this blood purifying spring water.

Once a place where people would seek healing, it now is slowly being taken apart and will soon be entirely gone.

D riving down a dirt road alongside the beautiful Lake Champlain, the remains of an all-boys camp can be found at the end. This large building once served as a meeting and function hall for the camp. The bunkhouses on the property all appear to have since been privately purchased and serve as camps for those who come here to enjoy the beautiful lake and property. This building, however, has been left abandoned and is now falling apart while life moves on around it.

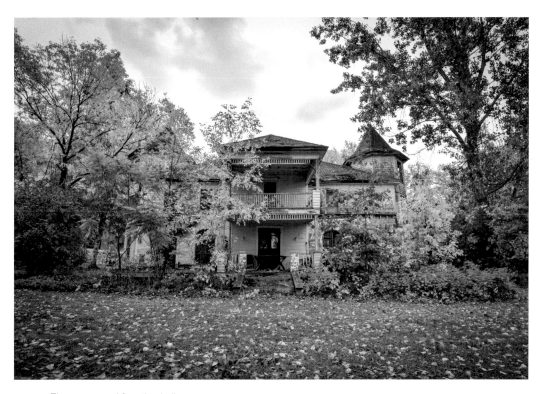

The once grand function hall.

2

FORGOTTEN FARMS

Much of my life was spent at my grandparents' house and the farm behind it. It was always the place I would go to when I needed a break from the world—whether it was to sit on the rock in the pasture and read, or to visit with the animals. It was always the place I would go to when I needed to shut out all voices but my own, so I could hear my own thoughts. I have more memories at that house, and on that farm, than I could even begin to count. Many of my biggest choices as an adult came from taking walks to the barn—including the decision to buy the house when I had the chance. I loved that house. I loved it until the very day it no longer fit the person I had become. And it was one day, after a walk to the barn, that I knew it was time to let go and move on. I had to shed my security blanket and see what else was out there, outside of my memories and comfort. The farm is gone now; another victim to the "American dream" of a *cul-de-sac* neighborhood filled with cookie-cutter houses. All the farms I have photographed have been left behind for various reasons, but they all share the reality that at one point, someone lived there and made memories in these places.

This house has such a deep, family history in the area. The couple who lived here used to rent out farmland to families for gardens and were well-admired by everyone who knew them. The neighborhood kids, even the ones who weren't related by blood, fondly called them "grandma and grandpa," and would play games outside on the farm. As the first family on the hill to get a television, they would have everyone over to watch shows. The upstairs, which was generally avoided by most of the kids, was rumored to be haunted by a ghost named Hiram. The once lively house sits empty now. The windows are gone, and the floors are caving in, but on a windy day, when the tall grass is swaying, you can imagine the children's laughter as they played out front, with this beauty, and maybe Hiram, watching over them.

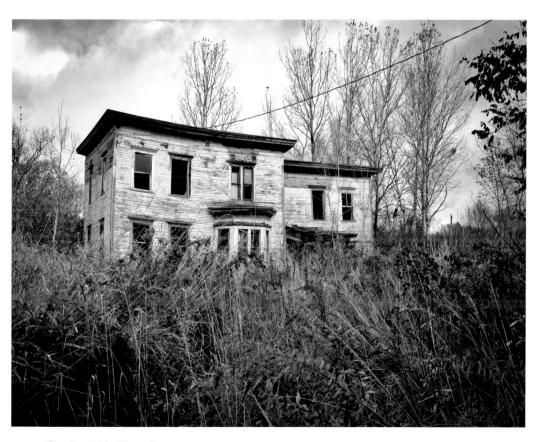

Standing behind the wall grass.

U p on a hill, barely visible from the road, this old stagecoach stop and inn has been sitting abandoned. In 1940, this house became home to a family who used the land for farming and who opened a farm stand and sold produce on the property. The family farmed the land until the day they left, leaving many of their belongings and memories behind.

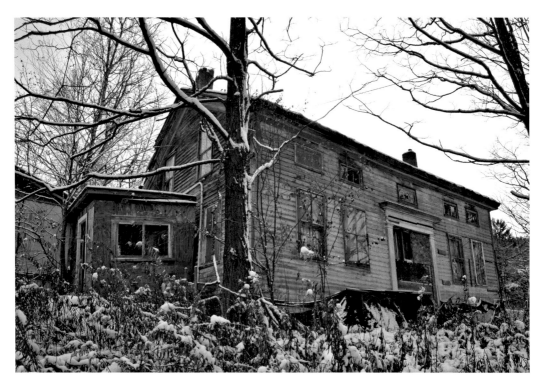

Hidden on a hill.

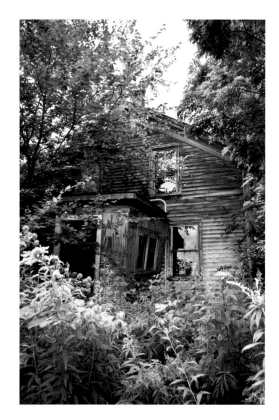

Right: Behind a wall of greenery.

Below left: How much tea was made in this kettle?

Below right: Farm stand where the family sold their produce.

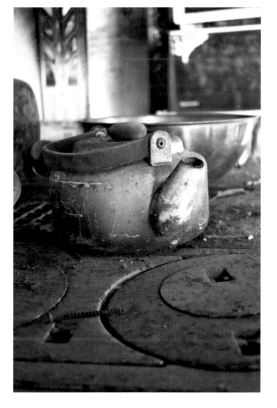

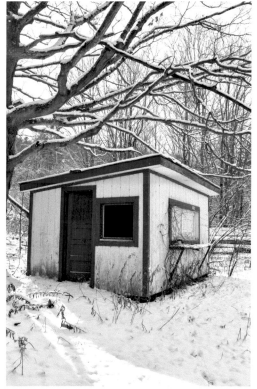

According to town records, this house was built in 1850. The land the house sits on, at that time, was owned by Theophilus Pond and would later be turned over to his son, Addison. The family also owned another house not too far away. Theophilus owned and ran a general store in town. Over the next 135 years, the house changed hands multiple times. Addison eventually sold the property in parts to a Civil War soldier named David Colburn and a farmer named William Peck. In 1865, they both sold their parts of the property to A. A. Moore. Shortly after, in the spring of 1870, Addison decided to buy back the property in its entirety. Keeping up with the consistent land turnover, he sold the property off to Porter Scott in 1873 who then turned around that same year and sold it to William Samson. William Samson built his factory on the land behind the house. He manufactured patented railway horsepower for running agricultural machinery. One of his catalogs from the 1880s is in the Smithsonian Museum in Washington, D.C.

Unfortunately, due to being struck by lightning, most of the factory burned. William Samson sold what was left of his factory back to Addison Pond, and the rest of the land with buildings to Francis Richardson. Just two short years later, Francis turned the house over to George Stevens, a farmer, for a dollar. George then gifted the property to his daughter and son-in-law. They eventually moved away in the mid-1930s but returned to the homestead in the late 1940s. George sold the house and all the outbuildings as well as 3/4 acres in 1985. The house has been vacant for many years since then, but the land is being used. Unfortunately, it now is completely derelict with no real hope of being saved before it crumbles to the ground.

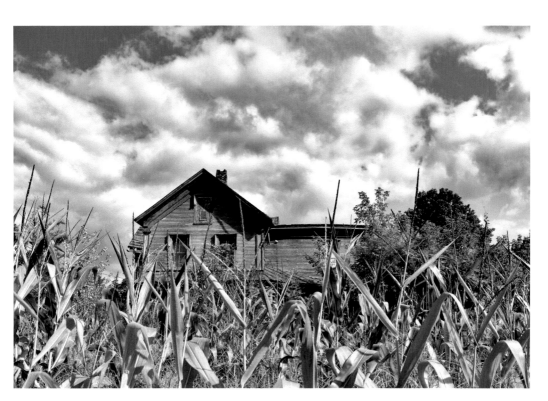

Hidden behind rows of corn.

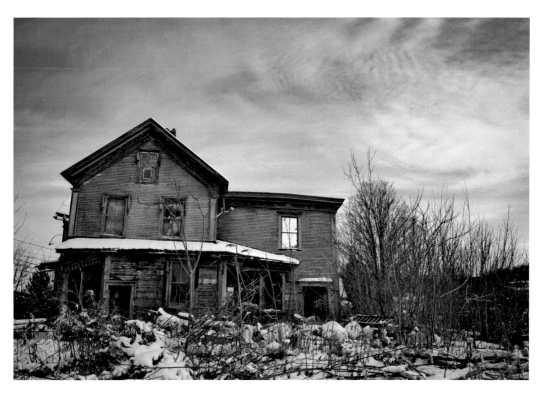

Seasons change. The roof of this house has started to cave in, giving a view of the sky from the upstairs window.

I was fortunate enough to speak with the woman who grew up in this house. Her father was hired to be the caretaker of this small, hardscrabble farm full of chickens and draft horses in 1959. Being the last town in Vermont to get electricity, they did everything by kerosene light for many years. For entertainment, the family would gather around the piano in the small, floral wallpapered living room, and her mother would play while the woman, who was then a child, would sing, the music carrying through the stillness of the dead-end mountain road. She moved out when she was eighteen and the house has stood unoccupied by anyone for at least twenty years, left to fall apart surrounded by mountains and memories.

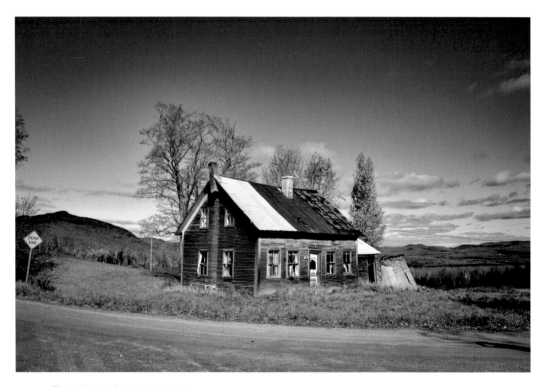

The stillness of a dead-end road.

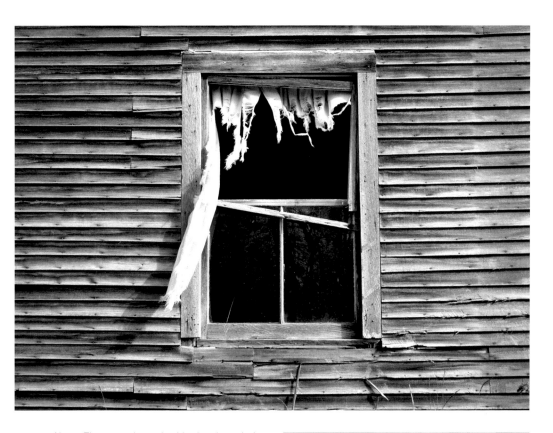

Above: The tattered curtains blowing through the broken windowpanes.

Right: Mountain views through the kitchen windows.

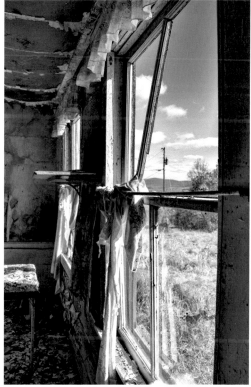

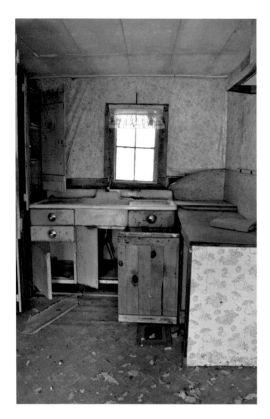

The wallpaper was different in each room of the house. The kitchen was a bright, vibrant yellow.

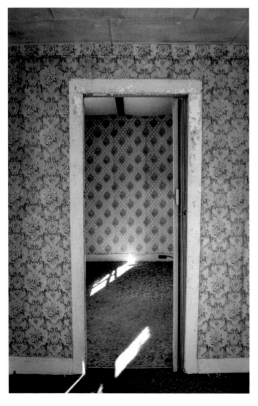

The rooms in the house were small, but cozy.

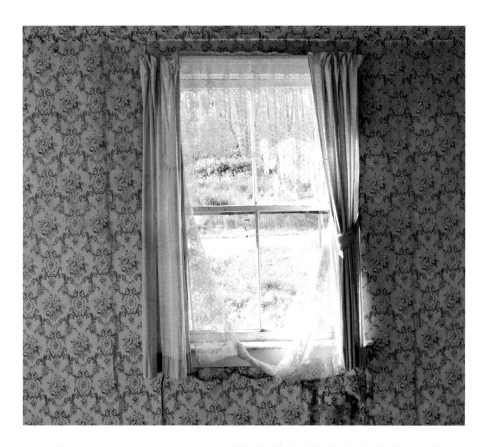

Above: Each room had curtains that matched the wallpaper.

Right: A small kitchen table in the kitchen.

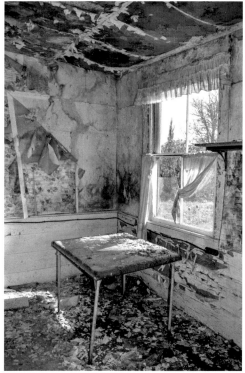

B uilt in the late 1880s–early 1900s, this house was for the families of those who worked on the over 200-acre dairy farm. In the late 1930s, a family lived in the house with nine children and no electricity or running water. The granddaughter of the family who owned the farm played and went to school with the children of the workers. After high school, she moved away from the farm, and the worker's house was then rented to a man and eventually the woman he married and her children. He would go to the town dump every Saturday, after everyone had dropped off all their junk, and he would put it out on the front lawn. It eventually became difficult to even see the house behind the wall of his junkyard findings. Sadly, several unfortunate and tragic events occurred in that house, including his wife passing away, one of the children being taken away, and the drowning of another child in the river nearby. The man who was living in the house tried to sue the farm owners, claiming eminent domain, but he didn't win the case and moved on. The farm burned in the mid-1960s due to a grass fire, but the worker's house remained standing.

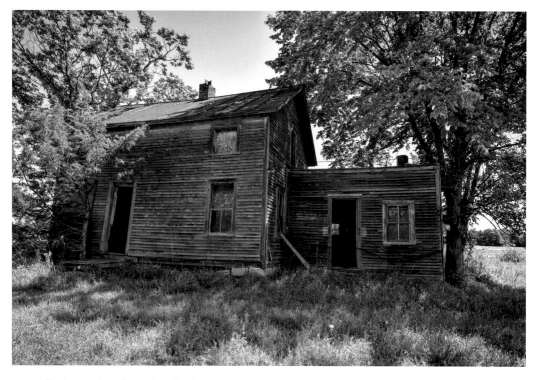

The house where the workers lived.

In 1929, a man from Quebec moved to a farm in rural Vermont. He lived on the farm with his brother and his widowed mother. In July of 1949, he married a local schoolteacher. The farmer ran the dairy farm that they all lived on while his wife eventually went on to become the principal of the nearby elementary school until she retired in 1984. Sadly, after sixty-seven years on the farm, and forty-seven years of marriage, the farmer passed away. His wife passed away almost nine years later. They never had children of their own but were both survived by nieces and nephews. The house and barn are now empty and are slowly falling into disrepair.

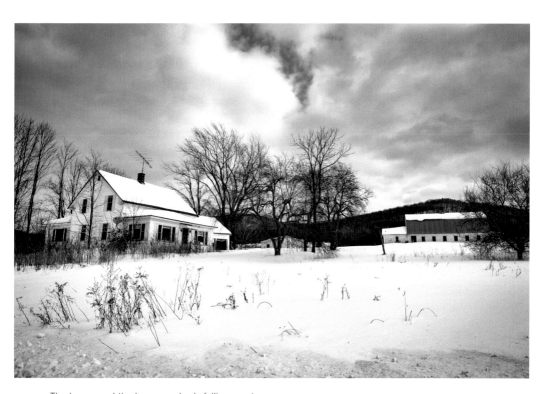

The house and the barn are slowly falling apart.

This home was one of the first to be built in the town in the 1700s. Like many other houses in Vermont, it used to be a stagecoach stop and some stagecoach roads still can be found weaving through the property, though many neighbors have since plowed over the connecting roads. Beautiful woodwork can be found hiding behind the porch addition. As with most uninhabited 300ish-year-old houses, it has started to sag and fall apart, but the stories it holds remain.

Driving down backroads can mean coming across interesting places. This particular road led to what was left of an old farmhouse—sadly, mostly just the chimney and foundation due to a fire that had ripped through the home and destroyed it in a matter of minutes. Walking around the property uncovered old cars, trucks, tractors, gas pumps, bicycles, a woodstove, etc., scattered around the property and in the woods—all with vines and brush growing through and around them.

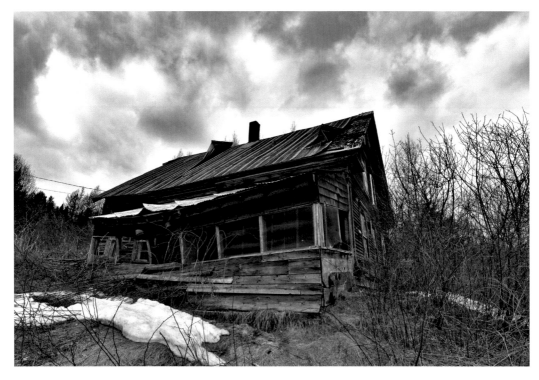

The porch is collapsing and the beautiful woodwork can be seen behind it.

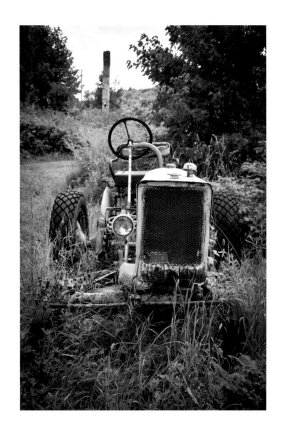

Right: A tractor in the long grass, with the remains of the old farmhouse in the distance behind it.

Below left: Vines overtaking an unused truck.

Below right: The gas pump was almost entirely hidden by grass and goldenrod.

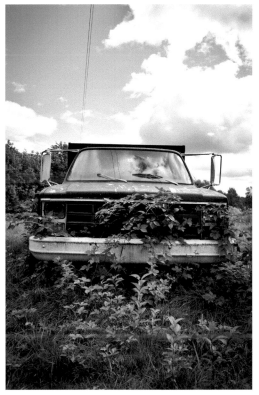

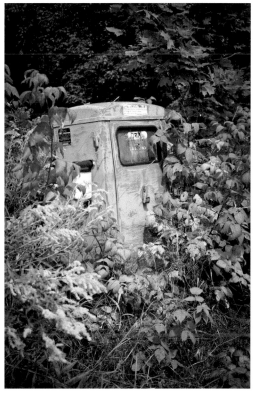

Some people don't see the beauty in the forgotten or the falling apart. I know it can be hard to see past layers of dust and dirt, growing thicker with every passing year, like the growth rings in an aging tree. And if you could just count those layers, you could figure out how long a place had been forgotten about. For me, the beauty lies in all the possible stories these places hold. It's easy to get caught up in wondering about all the people who once walked down these stairs or sat on the couch. What was their life like? What brought them here? What made them leave? Sometimes beauty lies in possibility and the unknown. This house sits on a hill above a beautiful, still lake.

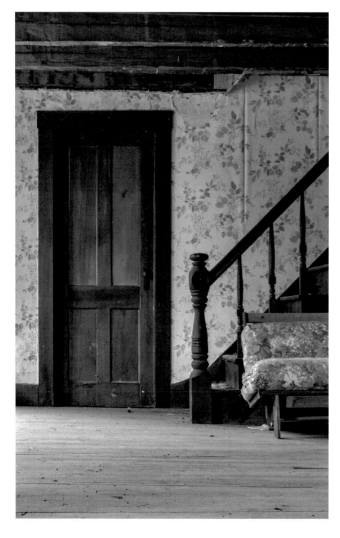

Layers of untouched dust on the floor.

Camouflaged behind a wall of trees on a long, winding backroad, you can find this house with dormers so steep they're the first thing you notice. Though it is now crumbling, it's easy to see the beauty that was once there. Built after the Civil War by Charles A. Story, a Vermont native and a veteran of the Union Army, this house—with the now caving roof, collapsed staircase, and crumbling entryway walls—was once his pride and joy.

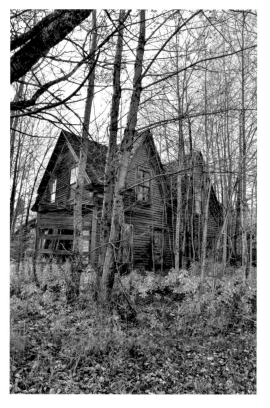

Sharp dormers peeking through the trees.

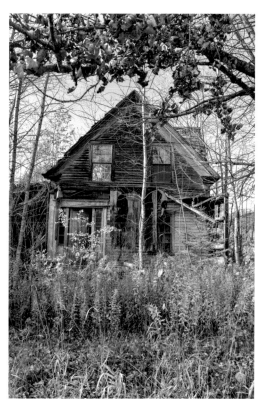

The front of the house is well hidden by trees.

When I was younger, I used to seek out the dandelions that my grandfather had missed while mowing the lawn. When they were in the "wishing" stage, I would make as many wishes as I could. One of my wishes was that I would always have that house to go back to in life, because it's where I've always felt safe. When I got older, and was able to, I eventually bought that house. And then I would sit on my lawn, making wishes on dandelions still. Eventually I started wishing for different things—things that would take me away from the place I had always wanted to live. Life has since taken me far away from that lawn and those dandelions. When I found this abandoned house, with a lawn full of dandelions, I couldn't help but wonder who had once sat there, picking dandelions and making wishes. I wondered if their wishes also took them away to somewhere else.

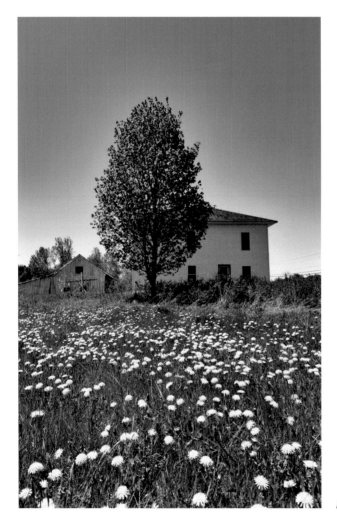

A field of dandelions.

Hardscrabble farms are very common sites rural Vermont. Abandoned houses with makeshift window or door coverings to keep the elements out are not uncommon either. Sometimes these places remind me of "playing house" as a kid with my cousins. We would use whatever we could find around the farm to make our "home" in the hayloft—whether it was haybales or old grain sacks, everything was fair game when being creative. This house utilizes shutters, an old door, and a potato sack to keep most of the snow and rain out, but like most abandoned places, some tell-tale broken windows remain.

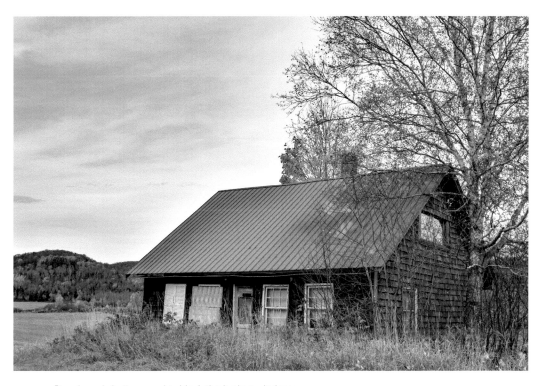

Boards and shutters used to block the broken windows.

An old potato sack used as a makeshift curtain.

The grass grew so tall; the window is almost covered.

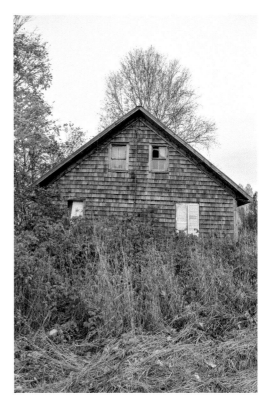

Right: More broken windows and makeshift coverings to keep the elements out.

Below: The peaceful, winding backroad where I found this house was breathtaking. The pond it overlooks was so still, it displayed vibrant reflections of the orange and red leaves of the trees surrounding it. The house itself appears to have been left alone for quite some time. The front stairs no longer exist to welcome people home. The broken, dusty windows reflect very little light through their cracked panes. But the undeniable beauty remains.

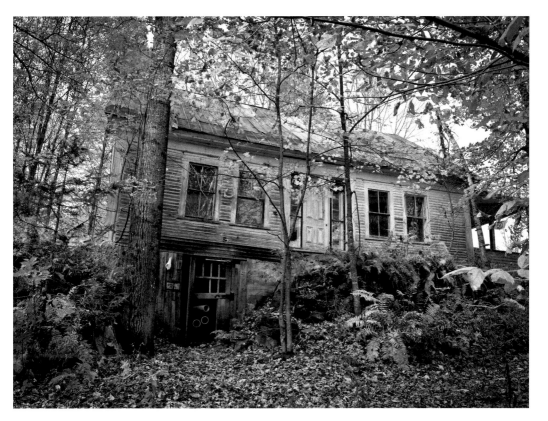

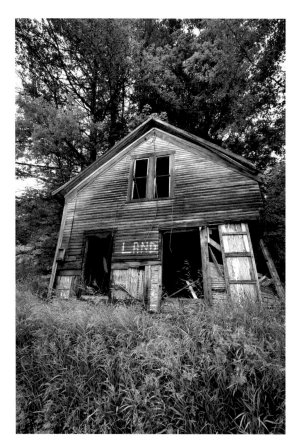

Left: When I first came across this old farmhouse, it was still standing for the most part. Currently it is now more of a pile of wood than an actual structure. The back and sides are almost completely crumbled and soon, nothing will be left of the wallpapered walls. It's so far gone, that all it's good for is the land.

Below: Up on a hilltop, this large farm is barely standing. The front porch has started falling in on itself and the thorns and brush have taken over the steps leading the way in.

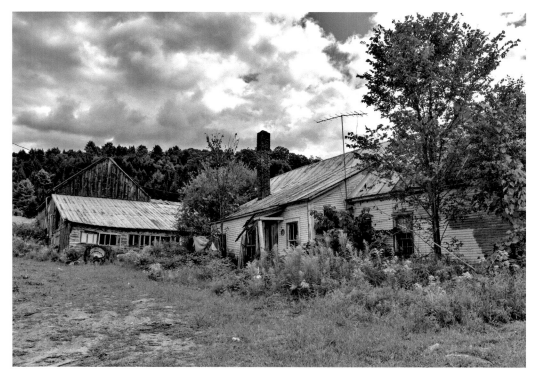

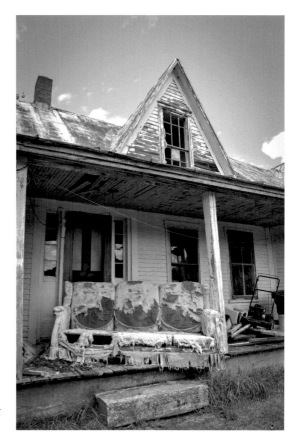

Right: The back porch seems like a catchall for forgotten and discarded belongings.

Below: A child's bike, no longer being loved or used, is among the pile of forgotten treasures.

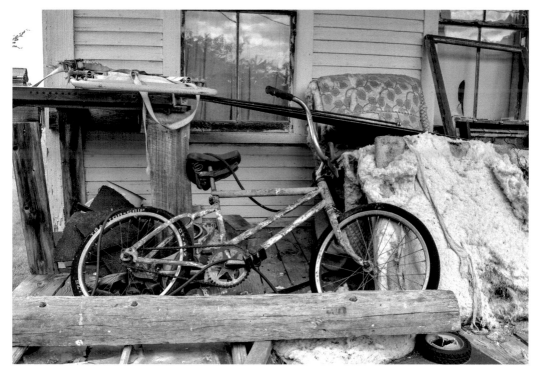

I remember gathering around the giant, clunky, wood-encased tube TV in my grandparents' living room. Growing up with a farm in the backyard, TV days were mostly saved for when it was too rainy or snowy and my cousins and I couldn't be outside playing. Seeing this TV brought back memories for me, but also made me think about the family who once lived in this old farmhouse, and who also used to gather around it, watching their favorite shows. Some of the items that get left behind in these old farmhouses always stir memories inside of me.

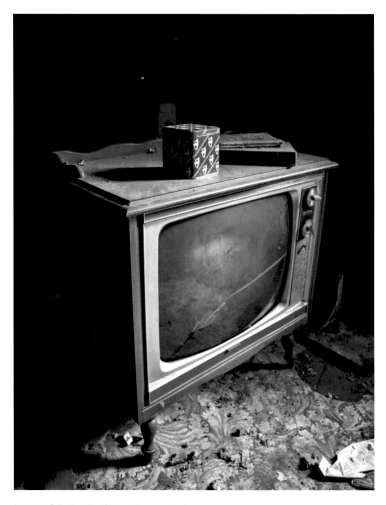

Layers of dust collecting on the cracked screen.

D espite the peeling, fading paint, and the decaying and crumbling porch, it's clear that the house behind this wall of lush greenery was once stunning. Built in 1898, this house was owned by a husband and wife until it was later purchased in 1987 and turned into an inn, which is what it remained until it was abandoned. In 1994, this house was even featured in a book titled *America's Painted Ladies: The Ultimate Celebration of Our Victorians*. Now it stands on the main road, falling apart as cars drive by it, forgetting about its past.

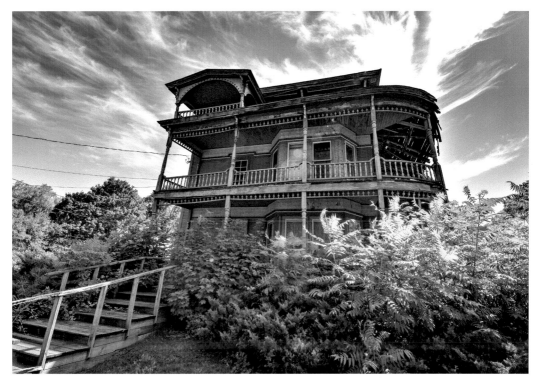

The beautiful paint is now faded, and the once grand porch is starting to give up.

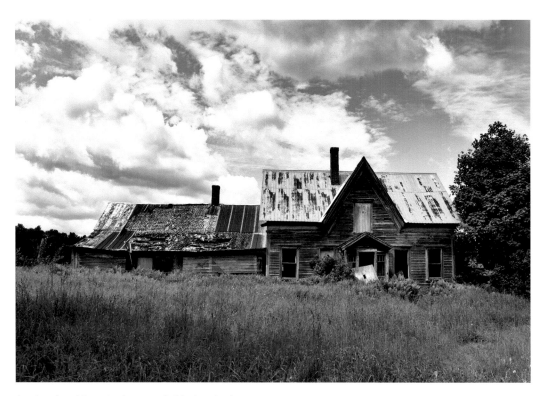

An abandoned farmstead surrounded by farmland

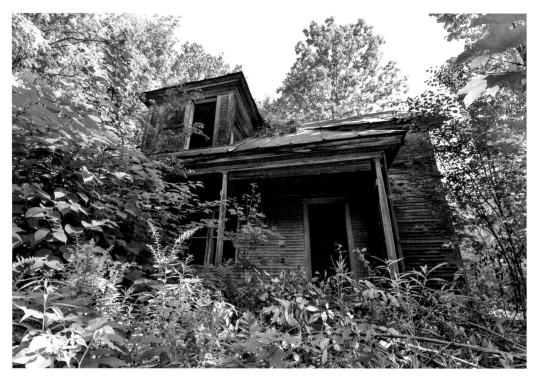

Nature has a way of trying to reclaim abandonment.

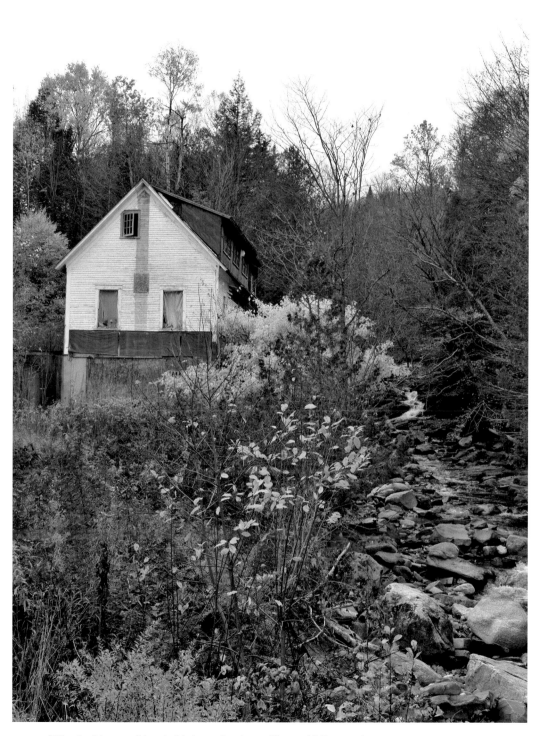

Sitting beside a small brook, this house has been sitting and falling apart.

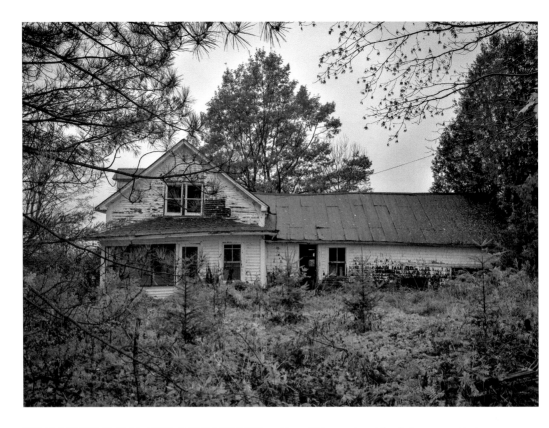

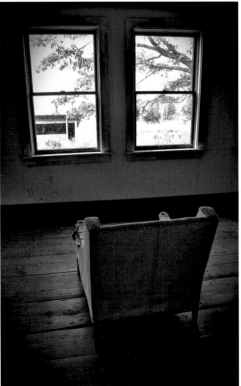

Above: This once loved family home once had children running around and playing basketball out front. The wide-planked floors inside show signs of the many people who have walked on them over the years.

Left: A lonely chair facing a window, waiting for someone to come back and sit in it.

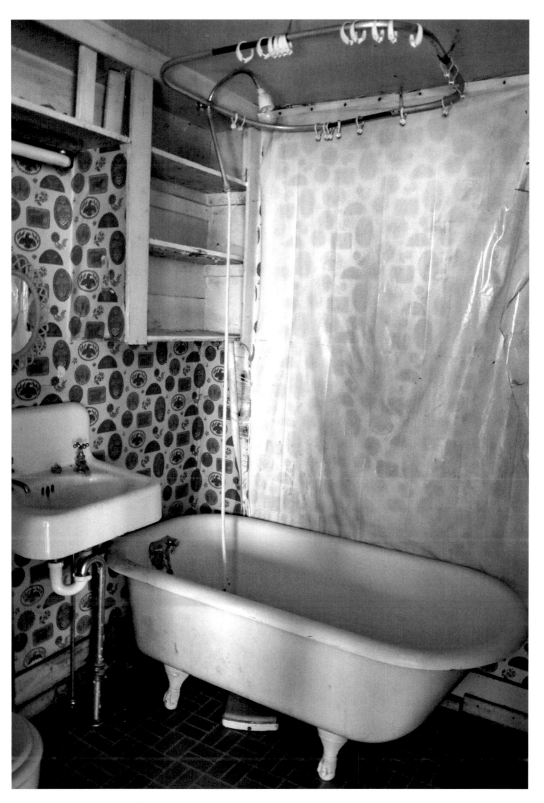

The bathroom had vintage wallpaper.

According to neighbors, the man who once owned this house lived alone, but had many dogs for companionship. The house has remained empty since his passing years ago, but the many notes found scrawled on the remaining wallpaper and the beautiful piano that was left behind tell part of his story. The intricate details on the porch reflect a level of craftmanship that we don't see very often anymore. Several of the windows are beautiful, colorful, leaded glass. The sunlight shining through them casts a rainbow across the floor.

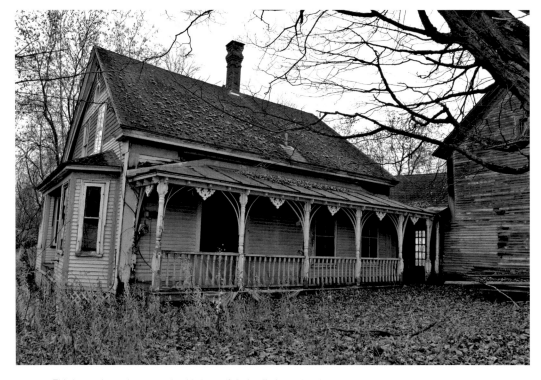

This house has a large porch with beautiful, detailed woodwork.

Opposite page

Above left: Some of the left-behind notes that are scrawled on the walls all around this house.

Above right: Some of the windows and doors are a beautiful stained, leaded glass. This door gives an outsider a view of the abandoned piano left inside.

Below: This once family-owned maple syrup business is falling apart on the side of the road.

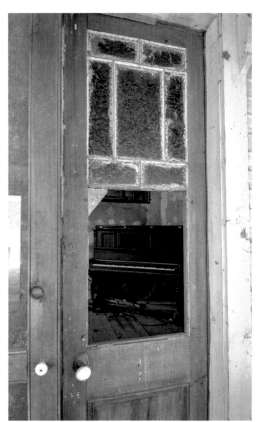

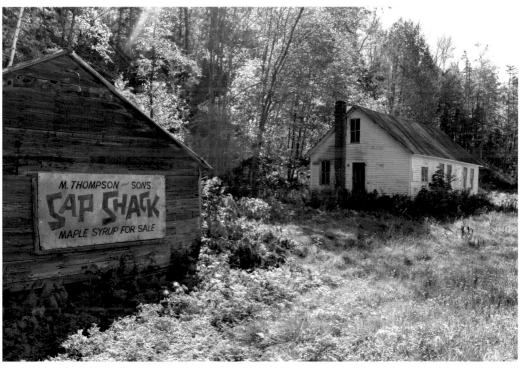

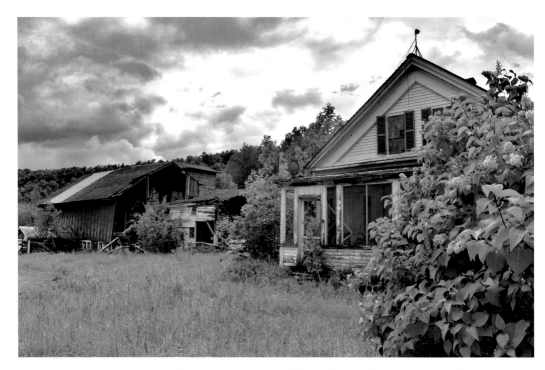

It's not uncommon to see large, rambling farmhouses with additions added on, often connecting the house to the barns. Sadly, it's also not uncommon to see these additions being the first part to start to crumble. In the case of this house, that's exactly what has started to happen.

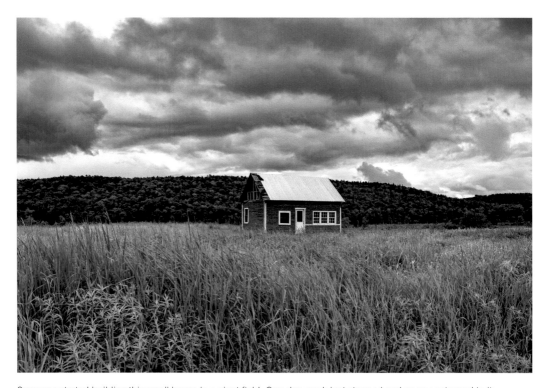

Someone started building this small house in a giant field. One day, work just stopped and no one returned to it.

B uilt between 1873–1876, this 75-acre farm has been called by several names before landing on the name it has had for many years. The land has changed hands many times over the past 200 years. In the 1970s, the farm was full of dairy cows, but that ended shortly after traffic started to pick up in the area. Though it sits neglected and unused now, vacationers and locals drive past it frequently—many unaware of its very long and deep history to the area.

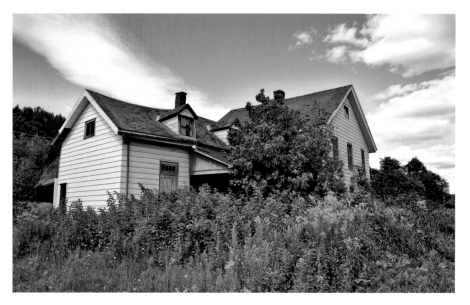

The main farmhouse becomes quickly hidden and overtaken by brush and vines in the spring and summer months.

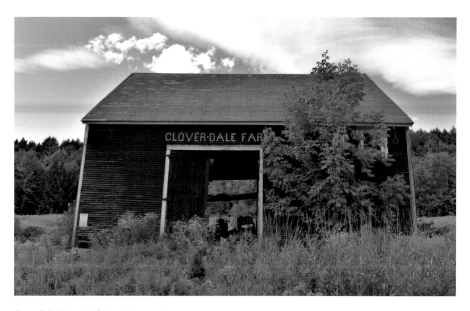

One of the barns left standing on the property.

I n northern Vermont, not far from the Canadian border, this old farmstead stands behind a wall of vines. The welcome signs on the porch are a start juxtaposition to the vine and brush that stand guard along the once well-traveled walkway. In the summer, the vines bloom into beautiful pink roses, the thorns making it difficult for any unwanted visitors to find their way inside. In the winter, when the branches are heavy with snow, the silence is almost deafening.

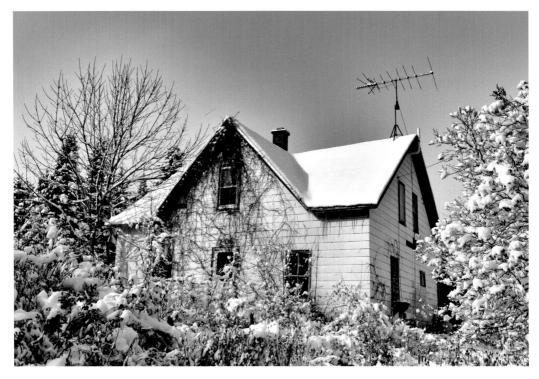

The dead vines on this house are holding on, even when snow and icicles threaten to take them down.

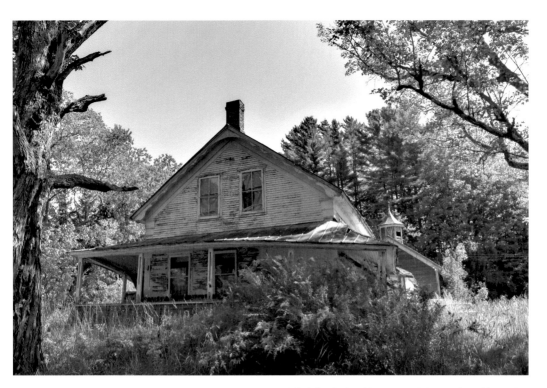

The grass has grown taller than the broken-down cars left sitting in the driveway, and the porch roof is starting to collapse.

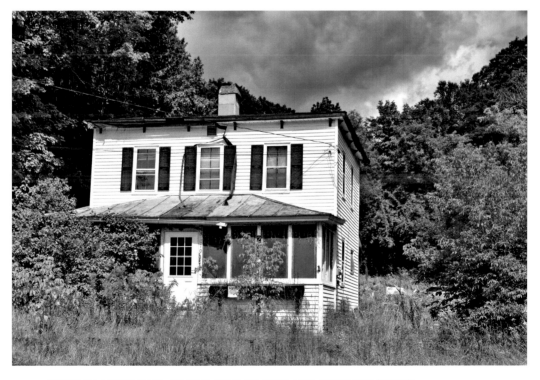

Despite the amount of snow Vermont gets in the winter, some houses have flat roofs.

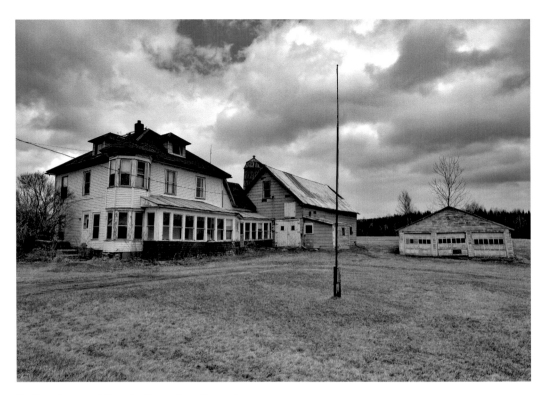

Another abandoned farmstead in northern Vermont.

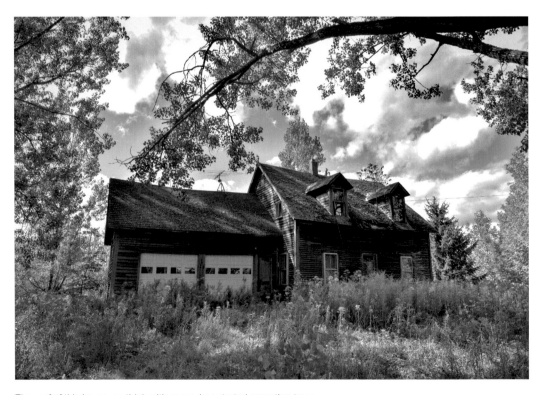

The roof of this house, so thick with moss, has started sprouting trees.

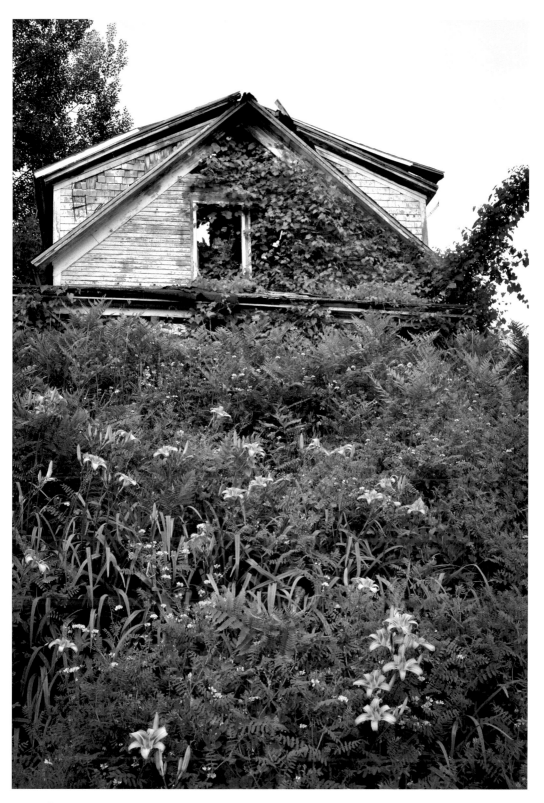

It won't be long before nature takes this house over entirely.

One of the oldest farmsteads I've photographed is one that I almost missed entirely because it was so well-hidden when the greenery was lush and full in the summer. It wasn't until I drove past it in the fall, when the leaves had died and the grass was the color of straw, that I was able to fully see the crumbling, ramshackle remains of what was once a large family farm. The leaning and sagging of the structure tells a story of decades of exposure to the harsh Northern winters.

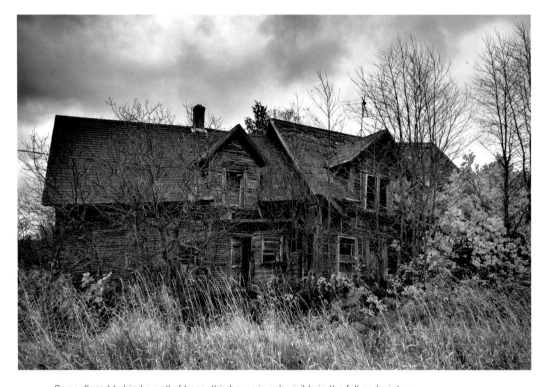

Camouflaged behind a wall of trees, this house is only visible in the fall and winter.

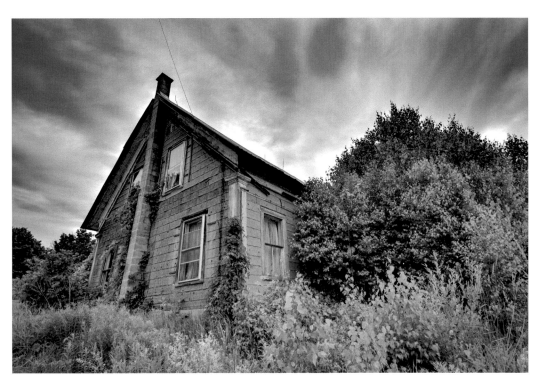

This farmhouse was left behind, and a new house was built on the farmland.

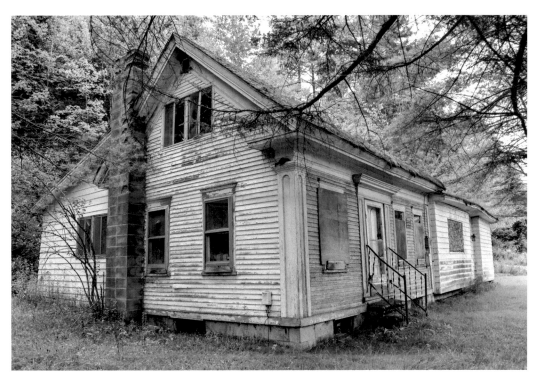

This house has been boarded up for years. It appears that a small fire happened, though I'm not sure if it was before or after it was abandoned.

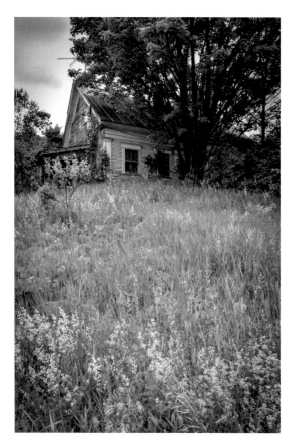

Left: Set back from the road, this house is almost entirely hidden by the large tree growing in front of it.

Below: I drive past this house frequently, and for the longest time, all the doors were wide open. It sits very close to a busy road, a road that most likely didn't exist when the house was built. Nothing is left inside, but it's clear that this house was once quite beautiful.

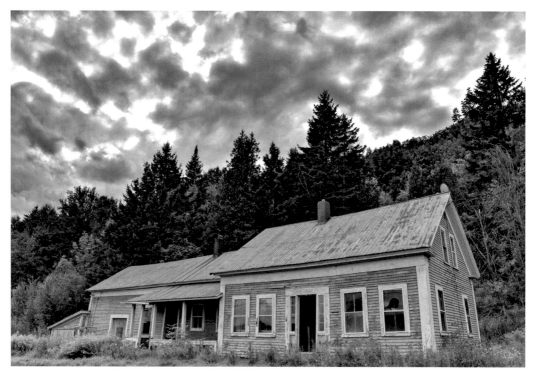

A once busy and booming railway town is where this beautiful, but somehow haunting home stands, neglected and forgotten. Neighbors speak of a tragedy that happened here decades ago, and the fact that many of the belongings were locked up inside, like a museum. Despite it being boarded up, the architecture of the house, with the corbels and the bay windows, both up and downstairs, is a reminder of a time when detail work and unique touches were commonplace.

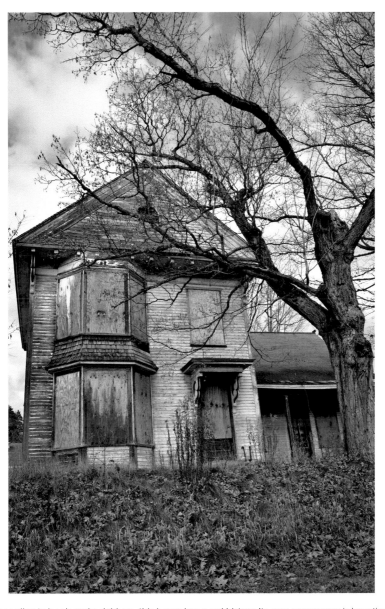

According to locals and neighbors, this house has a sad history. Its very appearance is haunting.

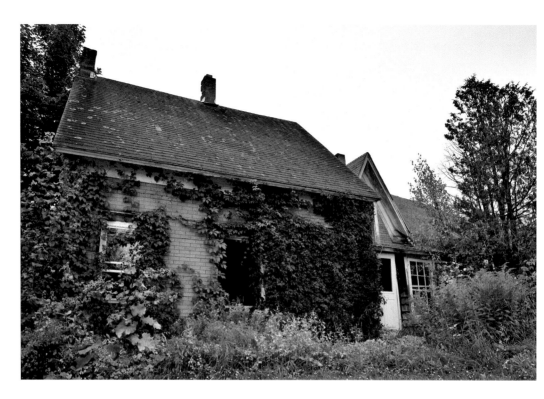

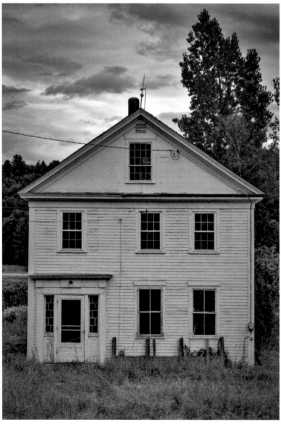

Above: Once part of a much larger old, family farmstead, this house is now standing on land that has been divided into plots, slowly falling apart.

Left: This house stands in the middle of the town center and is rumored to have once been a stagecoach stop and inn.

G etting close to this house was difficult due to how quickly the land flooded after it rained, and how long and thick the grass was, making it difficult to see the ground. Once I was able to get close enough, it was obvious that the house had been abandoned and neglected for a while. The windows, for the most part, were all broken and missing, though a few curtains somehow remained intact and were blowing in the wind. The porch was falling apart and the floors inside were sagging, as if they were ready to give out at any moment.

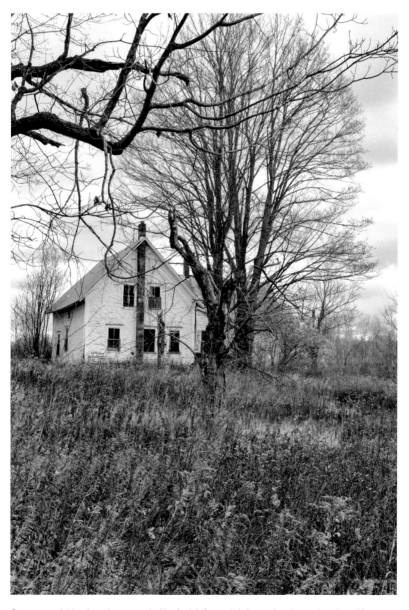

On a very quiet backroad, surrounded by Amish farms, this house has been abandoned for years.

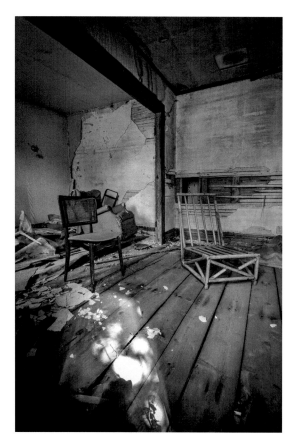

Left: All that was left behind in this house were a few chairs.

Below: Just outside of the area known as the Bennington Triangle, this house stands, boarded up and falling apart.

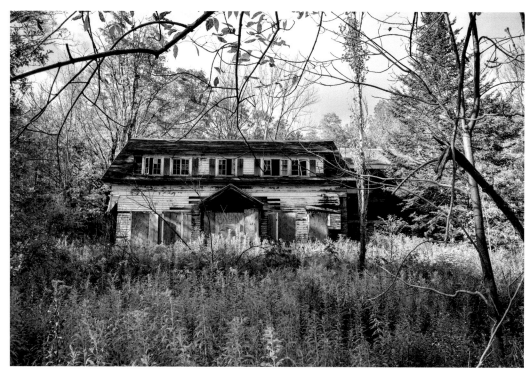

Vandalism is all too common when it comes to abandonment. A couple of years ago, kids were caught setting a small fire inside of this house. Fortunately, not much damage was done and this large, 1700s brick farmhouse remains standing. Over the years, it has become one of the more well-known abandoned houses in the area, which can bring more people and potentially more issues. The original embossed tin ceilings remain intact as does the original fireplace in what I assume was once a sitting room. With every passing year, the likelihood of this house being restored to its former beauty dwindles.

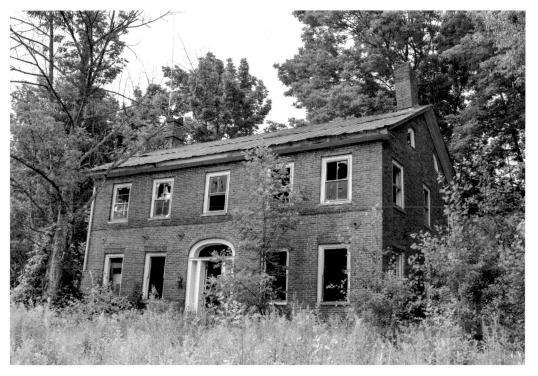

This old, 1700s, brick farmhouse has been vacant for many years. It has fallen victim to some vandalism, but its bones remain strong.

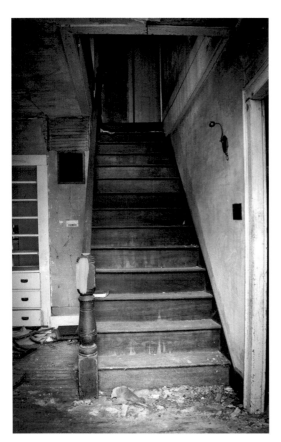

Left: Staircase leading to the empty rooms on the second floor.

Below: Behind a wall of trees, the front door and a large porch are hiding.

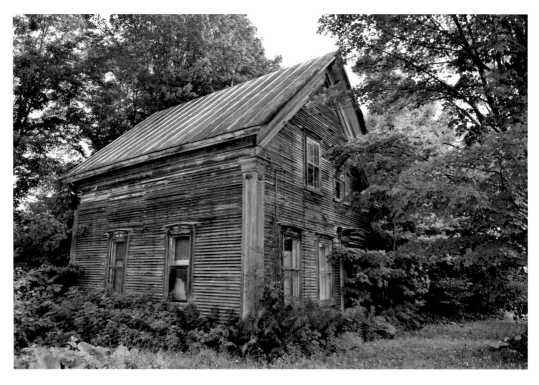

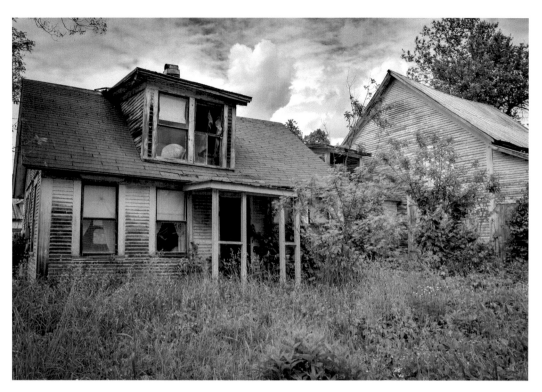

Even though this place is visible on a well-traveled road, it still always appears forgotten and neglected.

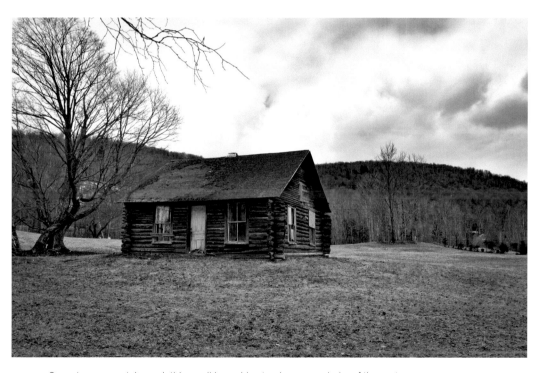

On a steep, mountain road, this small log cabin stands as a reminder of the past.

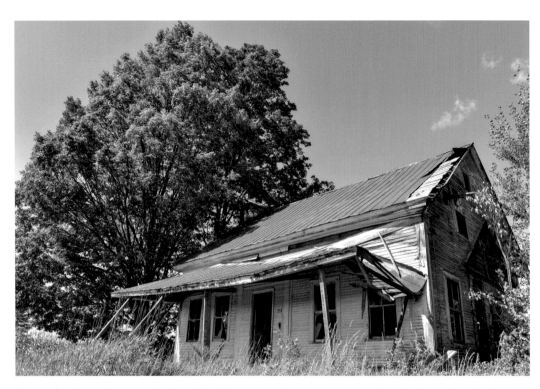

The porch roof started to sag and fall on this old farmhouse, but someone propped it up in hopes of saving it for a short time.

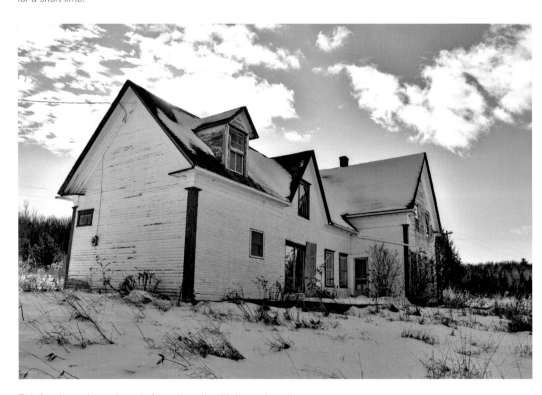

This farmhouse has sat empty for so long, that it's beyond repair.

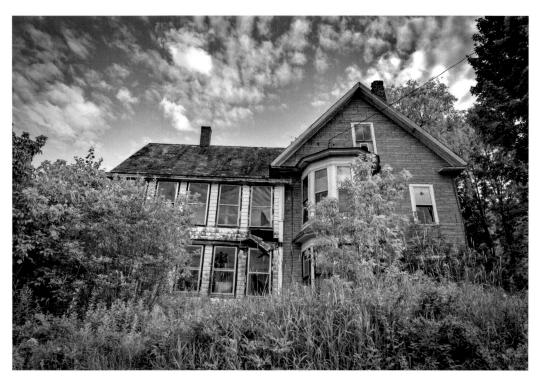

Many towns in Vermont used to be busy epicenters of tourism due to the railroads connecting areas with Canada and Boston. Once those stopped running, these areas lost a lot of commerce and tourism.

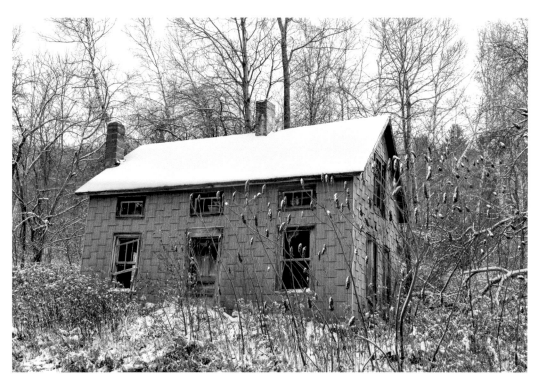

This house sits on a busy road, surrounded by neighbors, while it crumbles.

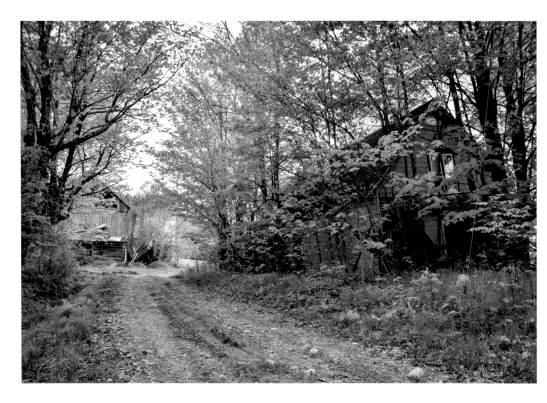

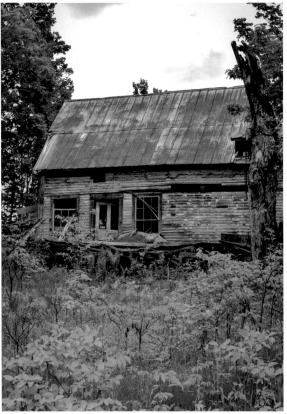

Above: The entire back half and second floor of this large, once rambling farmhouse have fallen in completely.

Left: This large, old farmstead has been left in complete disrepair.

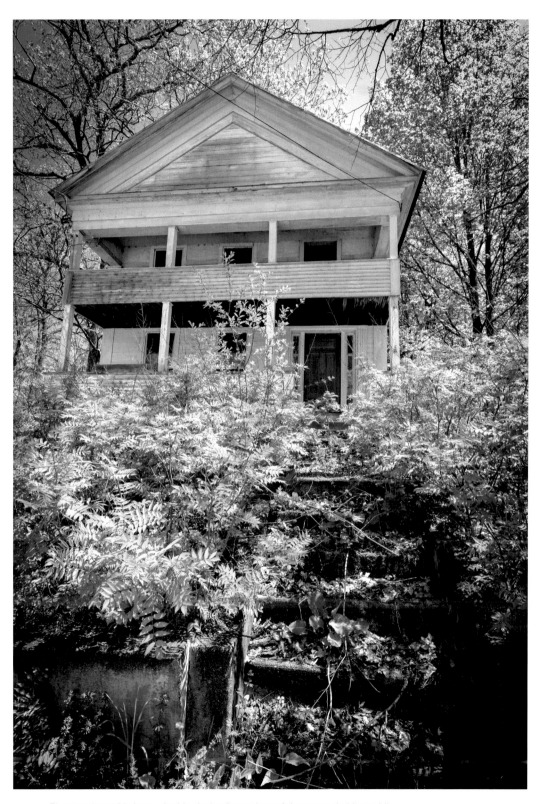

These stairs to this large, double-decker house haven't been traveled in a while.

It's a different level of sadness when I come across a place where things were left behind, almost as if they were waiting for their owner to return. The pink bedspread and homemade throw blanket, as well as the robe hanging on the door, made me wonder who had lived here. Did they make their bed expecting to come back? Did they hang their robe expecting to put it on again that night? Why didn't they return? Every house has its own story and memories, and it's during moments when I'm standing in rooms like this when I remember that.

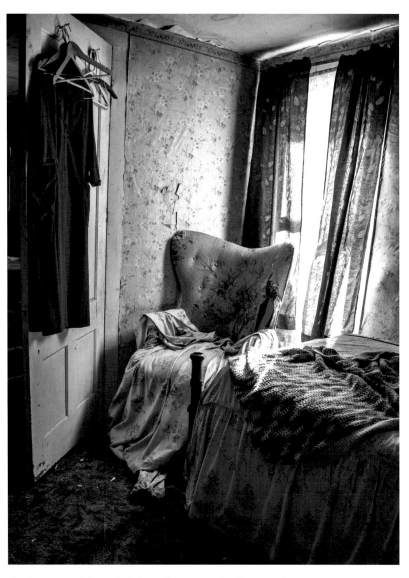

This house especially reminded me of the cabins that first started my abandonment journey. The bed was made, and the robe was hung on the door, as if waiting for someone to come back to the room.

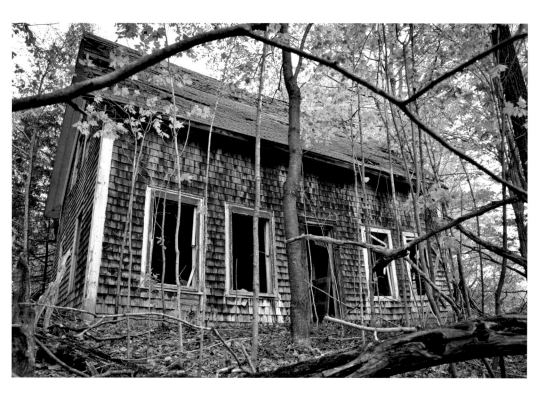

Above: This house is almost impossible to see in the summer and fall, when it's hidden behind a wall of thick trees and brush. It's only in the winter and early spring that you can see this house on the side of the road. It has been here for so long, that there's no longer any kind of visible driveway or way to get to it, unless you climb through a ditch and up the hill.

Right: The wagon wheel has been sitting for so long in front of this abandoned house that a tree has grown around it.

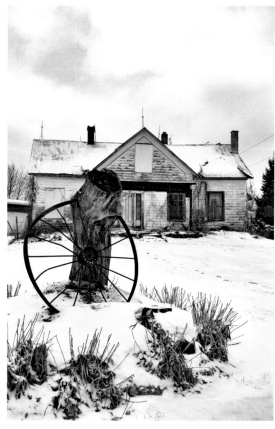

This sprawling house was rumored to once be a tuberculosis hospital and then a home for the elderly, with the nurses' quarters located upstairs. A past tenant said that the home always gave her an uncomfortable feeling that she felt until the day she moved out. After speaking with a neighbor, I was told that this house was purchased and then left neglected and unused for years. She also felt that the house made her uncomfortable, though she couldn't pinpoint why.

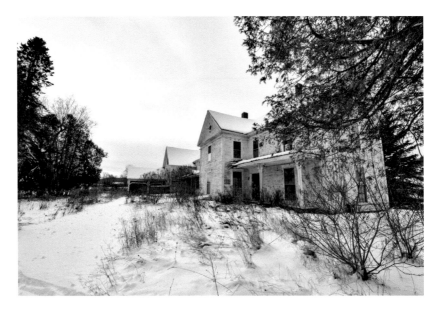

Standing alone in the winter stillness.

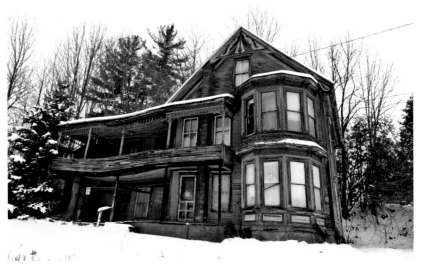

This house, with its ornate woodwork and drooping upper porch, has been through many cold, snowy winters in northern Vermont.

The beautiful stained-glass windows that once adorned this 1897 Victorian home have all been removed. Looking at it now, it seems to be only a shell of what it once was. The turrets remind me of fairytales that I used to read as a child. The house has been abandoned for years and is slowly being taken apart and torn down to make way for something more modern. One of the turrets has a secret passageway to get into it, which makes me wonder what mysteries this house used to hide.

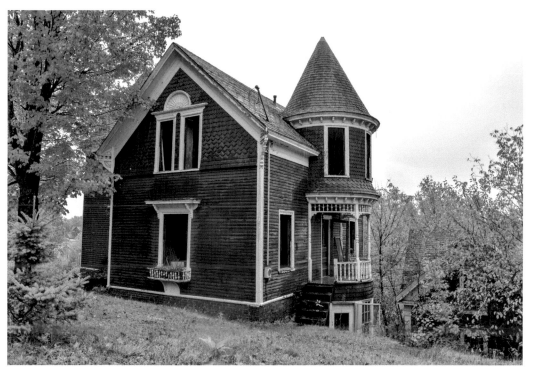

The beautiful stained-glass windows that once adorned this 1897 Victorian home have all been removed. Looking at it now, it seems to be only a shell of what it once was.

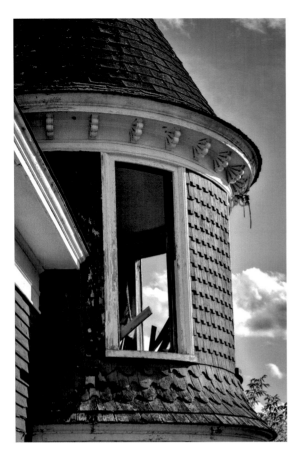

Left: One of the turrets of the Victorian house.

Below: Found at the bottom of a hill on a campground.

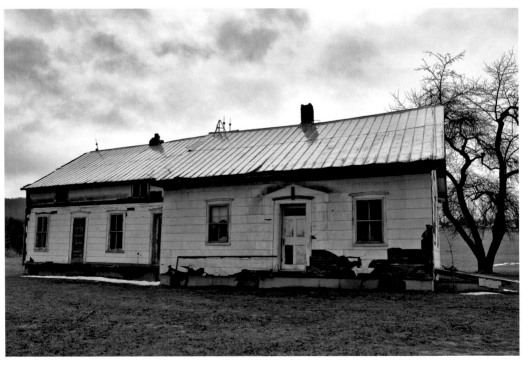

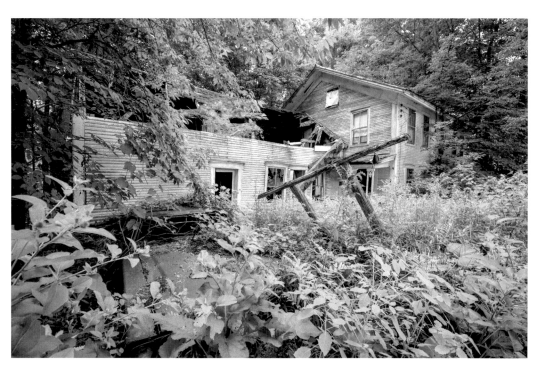

When I came upon this house, I noticed a few things immediately – the caved-in roof, the broken windows, the tall grass that seems to be growing both in and outside of the house. What I didn't notice right away, until I got closer, was the rusted car, buried beneath vines and tree branches.

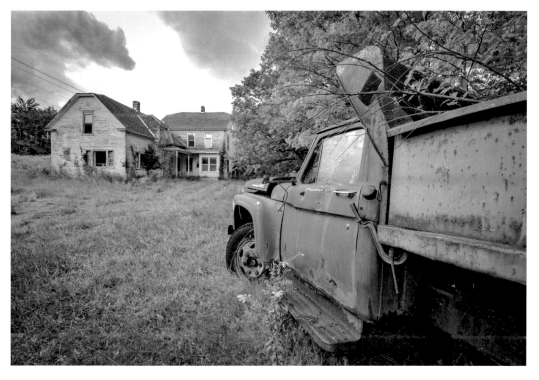

An abandoned farmhouse and truck in the fading evening light of autumn.

3

FORLORN PLACES

Old one-room schoolhouses, small churches, family-owned country stores, and barns are things that almost every town in Vermont have in common. These things are part of what make small towns in Vermont seem so quaint and picturesque.

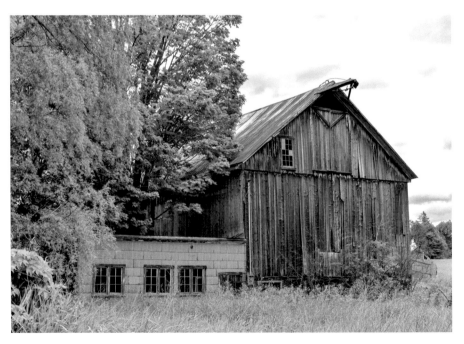

The farm that this barn stands on has been long abandoned, but like many old farmsteads, the land is still in use.

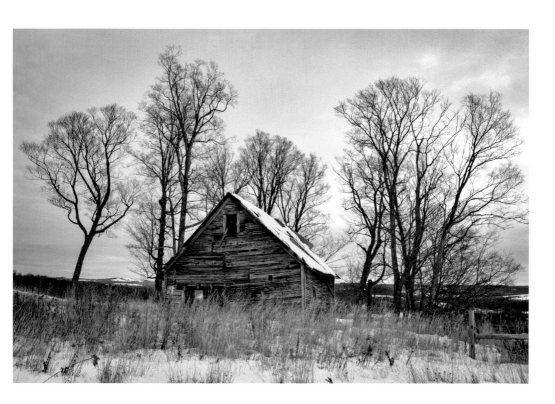

Above: One of the first things I noticed when I moved to the area I live in was this crumbling barn in the field near my house.

Right: A long forgotten silo in the middle of a giant field.

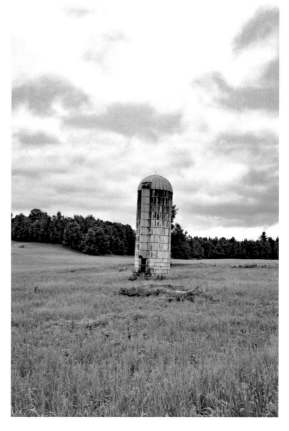

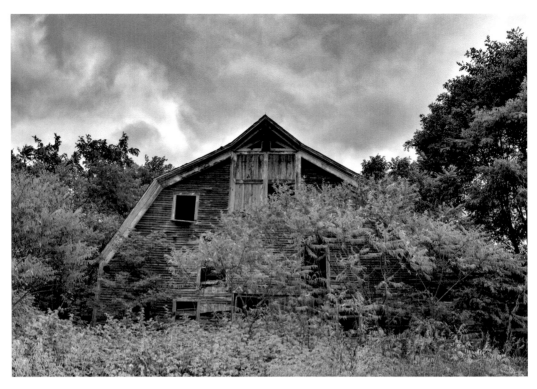

Another old barn that hasn't been in use in years.

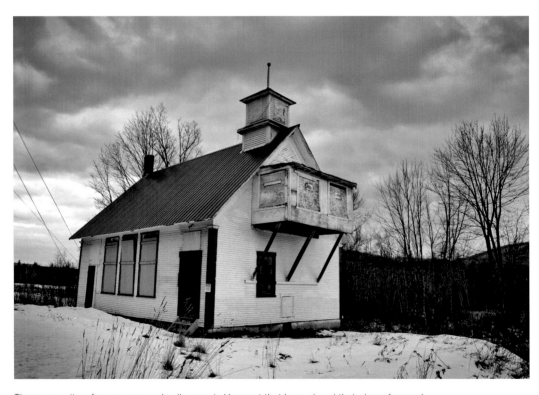

There are quite a few one room schoolhouses in Vermont that have closed their doors for good.

D riving down backroads is a good way to find long-lost history. Sometimes it's hard to figure out the history of a building simply by just looking at it. But many schoolhouses in rural Vermont share similar architecture, which can help with piecing history together. The gable on the front of this schoolhouse has a placard that reads 1924—almost 100 years ago. Later converted to a residence, additions were added to the back of the building, including horse stables that have since fallen.

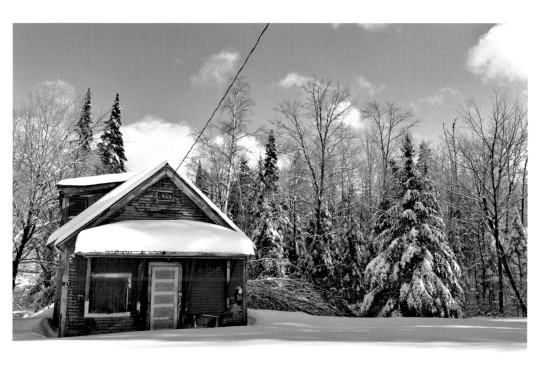

An old schoolhouse on a winding, mountain backroad.

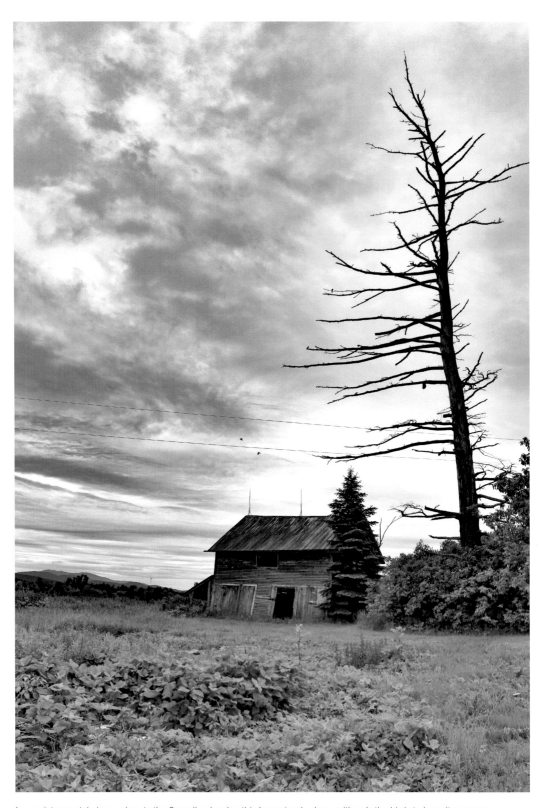

In a quiet mountain town, close to the Canadian border, this barn stands alone, with only the birds to keep it company.

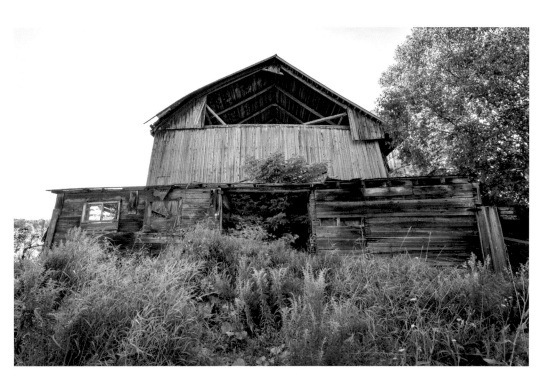

Above: This barn is part of a farm that has fallen apart. The barn itself has been deteriorating since I found it a couple of years ago.

Right: Tropical Storm Irene hit Vermont hard in 2011. One of its victims was this already run-down country store.

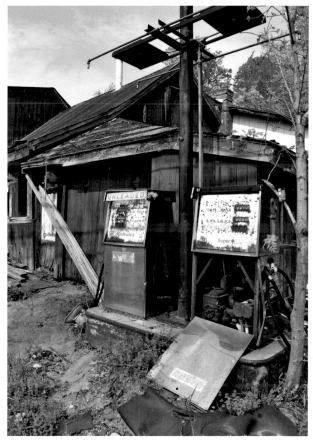

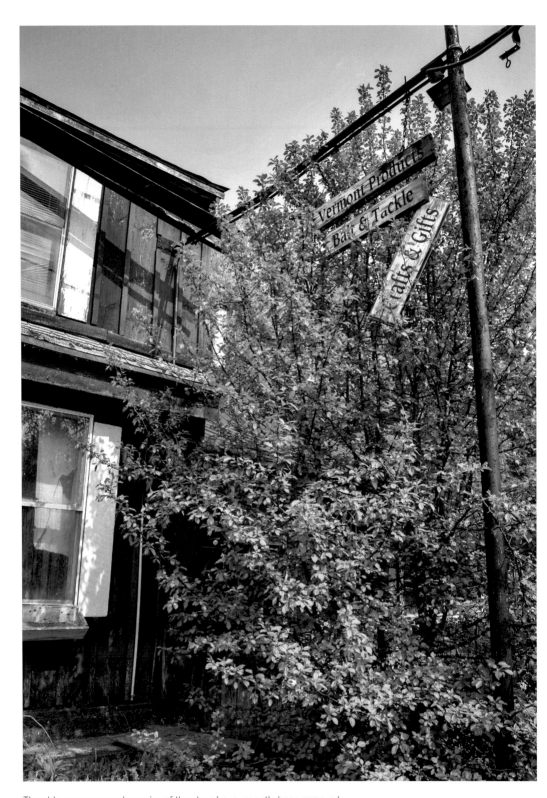

The old gas pumps and remains of the store have recently been removed.

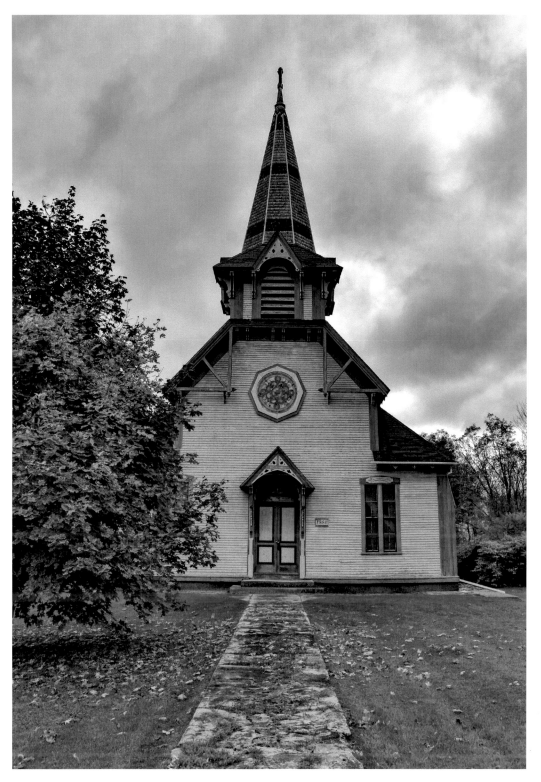

Built in 1880, this church was used for decades until it was deconsecrated in the early 2000s. It eventually fell victim to flood damage from Tropical Storm Irene.

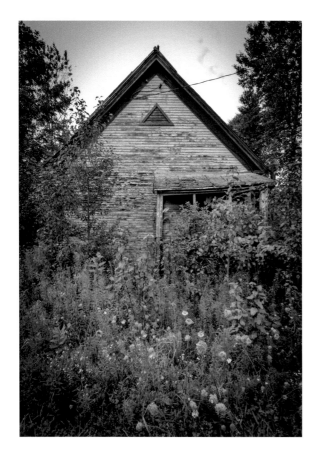

Left: It is said that this was once used as a dance hall, despite its diminutive size.

Below: Driving down another backroad, I was reminded of how resourceful Vermonters are. This slowly collapsing building, which was once a gas station, has old license plates in place of normal siding materials. It's such a unique building. I would have loved to see it when it was up and running.

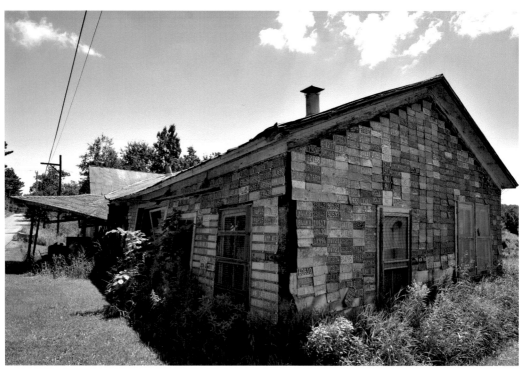

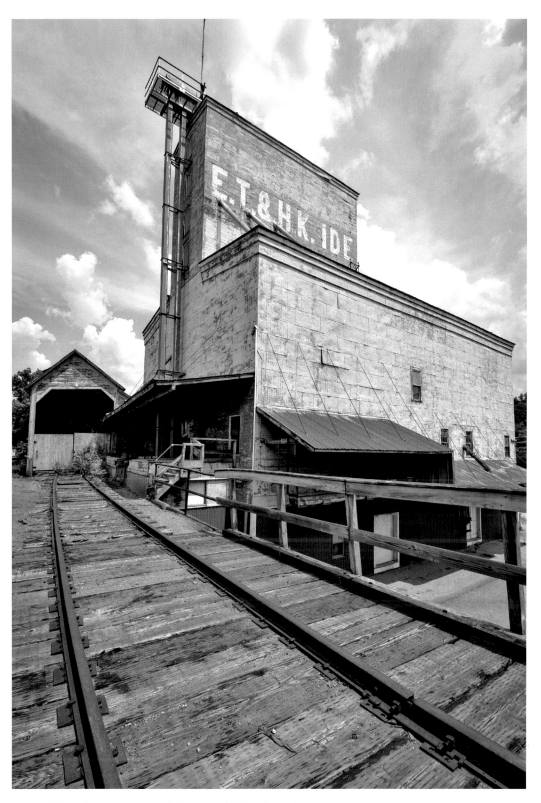

This grain company was built in the late 1897 and now sits empty.

Above: An old, defunct mini-golf and go-cart track has been sitting unused for several years.

Left: The golf course and go-cart tracks are all overgrown and unusable.

4

DISCARDED TRANSPORTATION

Admittedly, I am not someone who knows very much about cars. What I do know is that I like the look of vintage cars over anything new. The number of abandoned vehicles that I've come across while exploring across the state is much higher than I would have ever anticipated. Most times it's a guessing game trying to figure out how long a vehicle has been left behind. Trees, grass, and vines can be found growing around and inside some of these long-forgotten vehicles.

Riverside Park in Agawam, Massachusetts, started as a picnic grove in 1870 and later became an amusement park in 1912. When the Wall Street Crash happened in 1929, the park was forced into foreclosure. There were several attempts to revive and reopen the park, but it remained closed until 1939. Riverside reopened under new ownership in 1940. This is when the Thunderbolt, the wooden coaster that still stands today, was built. The park continued to operate under the "Riverside" name until 1999 when it became a part of the Six Flags chain.

This abandoned double-decker bus, believed to be from the 1970s, has somehow found its way to a field in Vermont, far away from where it used to carry around families who were enjoying the park and making memories.

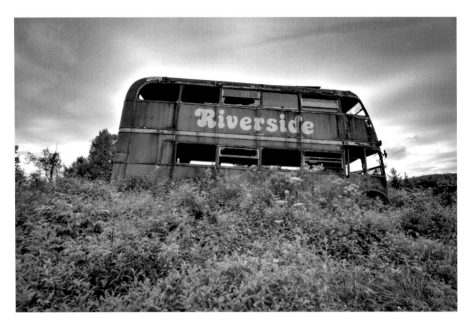

Far away from the liveliness of the amusement park, the Riverside Park bus stands alone in a field.

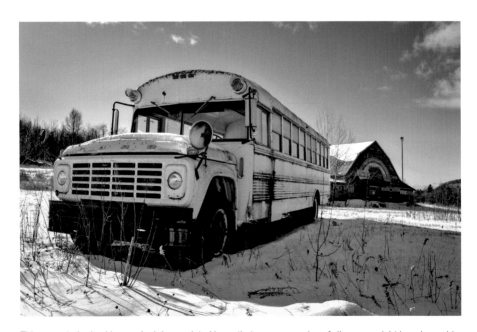

This converted school bus and rainbow painted barn, that was once a sign of vibrance, might be salvageable.

I n the middle of the woods in northern Vermont, this vintage, broken-down bus sits surrounded by streams, woods, and mountains. There must have been a road leading to this area at some point for it to have gotten to where it is, but that road is no longer visible or in use.

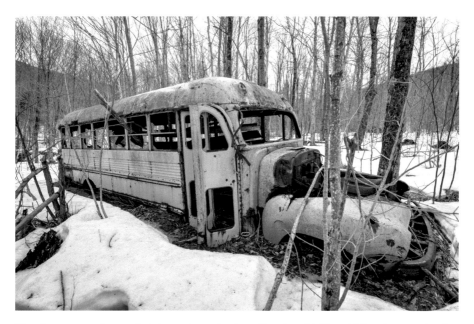

It's not uncommon for people to improvise and get creative when thinking of things to use as hunting blinds, so it's entirely possible that this derelict bus was once used for this purpose.

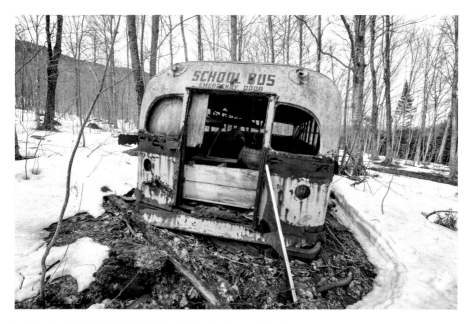

This bus was abandoned in an area with beautiful mountain views.

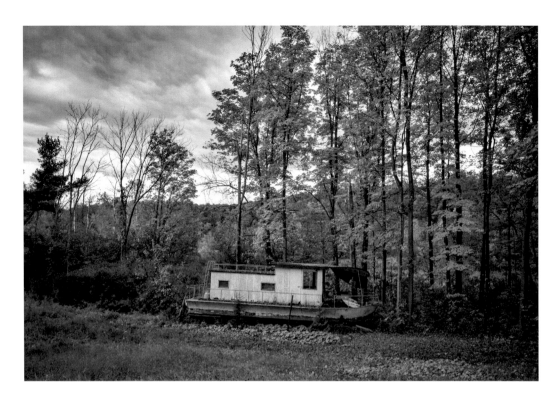

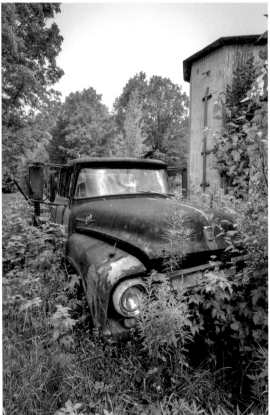

Above: Slowly falling apart, this boat has been sitting in a field for several years.

Left: Abandoned alongside a barn that used to host Saturday night dances, this truck sits rusting.

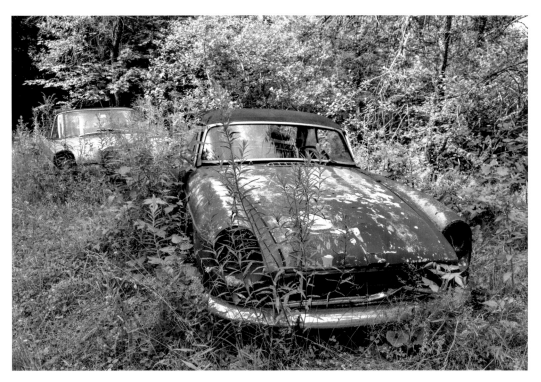

These cars were found in the woods on a backroad in northern Vermont.

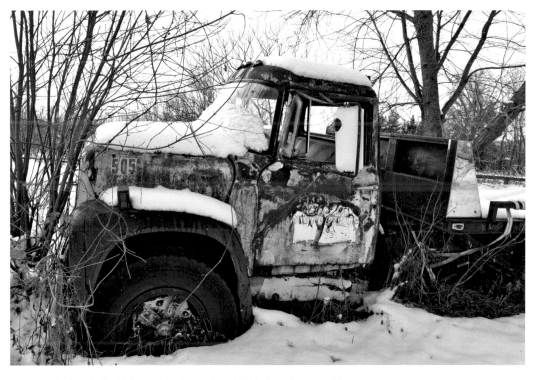

A junkyard of vehicles and boats was found behind an abandoned house.

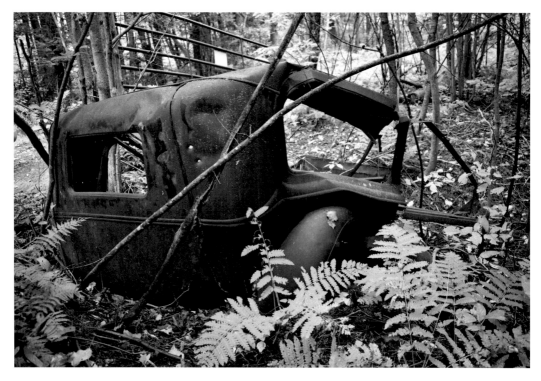

This abandoned car on the side of what is now a driveway immediately caught my attention. It's estimated to be from the 1930's. Much of the land around the house and road was all farmland for many years, and this most likely belonged to whoever owned this land before the house was even built.

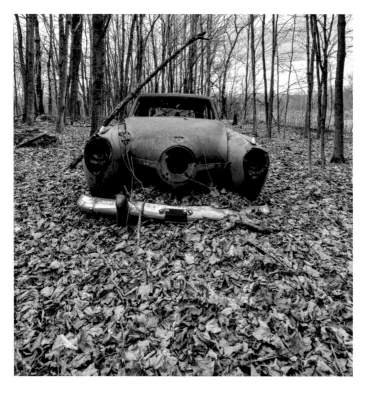

This old, 1950's Studebaker was found in the woods with a view of the mountains.

I chose for this to be the last photo of this book, because it speaks so much to what I find most beautiful about abandonment. Nature will always find a way to reclaim and persevere when it comes to the abandoned places and objects we come across. Even if it has been discarded and forgotten by people, nature will always be there to take it back. Life will always find a way to go on, even if it means growing through the rubble, crumbling walls, rust, and thrown-away memories.

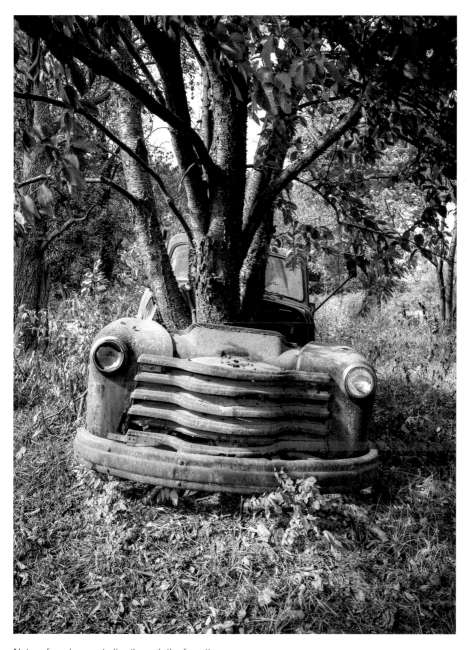

Nature found a way to live through the forgotten.

WORKS CITED

Berlin Historical Society

Preservationinpink.wordpress.com

Berkshire Historical Society

Obscurevermont.com

Vermonter.com

Chatham, P., *From County Cavan to Canada: The Simons-Simonds-Symonds Family* (Lulu.com 2014)

Vtcng.com/waterbury_record